OTTERY ST MARY
THROUGH TIME
Nigel Sadler

AMBERLEY PUBLISHING

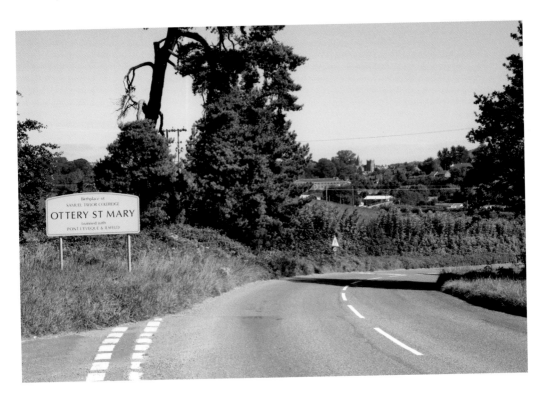

View of Ottery St Mary from West Hill, 2012
Ottery St Mary sits surrounded by countryside and is popular with walkers taking the trails along the River Otter and fans of Samuel Taylor Coleridge (1772–1834). This view shows just how green the town is and how it appears to rise from the countryside from certain views. If you think that Ottery St Mary sounds familiar, it maybe because J. K. Rowling named the fictional home village of the Weasley family in the Harry Potter series Ottery St Catchpole after Ottery St Mary.

First published 2013

Amberley Publishing
The Hill, Stroud
Gloucestershire, GL5 4EP

www.amberley-books.com

Copyright © Nigel Sadler, 2013

The right of Nigel Sadler to be identified as the Author of this work has been asserted in accordance with the Copyrights, Designs and Patents Act 1988.

ISBN 978 1 4456 0975 1

British Library Cataloguing in Publication Data.
A catalogue record for this book is available from the British Library.

Typeset in 9.5pt on 12pt Celeste.
Typesetting by Amberley Publishing.
Printed in the UK.

Introduction

Located 12 miles north-east of Exeter, Ottery St Mary is best known as the birthplace of Samuel Taylor Coleridge. However, there is more to this picturesque east Devon town with its wonderful thatched cottages, cob-constructed houses and buildings ranging from the eleventh to the twenty-first century. For nature lovers the River Otter provides a beautiful walk, linking up many of the towns and villages and often displaying the legacy of past developments, such as the mills and the old railway line. Then there are the locals, who provide a warm welcome to visitors.

In the BBC Radio 4 comedy series *Cabin Pressure*, the episode 'Ottery St Mary' had the plane's crew transporting a piano to a pub in the town. The co-pilot explained that the town gained its name because the patron saint of Devon, St Mary, had been mauled to death by a group of otters. This of course is not true. In Saxon times there was a settlement that took its name from the River Otter (then known as Otrig). In 1061 Edward the Confessor gave the manor 'Oteri' to Rouen, the historic capital of Normandy. It is recorded in the Domesday Book of 1086, but there is no mention of a church. In 1207, the town's name was extended to include 'St Mary' which indicated that a church existed, even though it is likely that a church in the region predates the Norman conquest.

There are now several definitions for what constitutes the boundaries of Ottery St Mary. There is the town itself. Then there is the historic parish of Ottery St Mary, which also covers the villages of West Hill, Metcombe, Fairmile, Alfington, Tipton St John and Wiggaton. And now there is the political definition of the 'Devon Towns', which are aggregations of parishes, with the following making up the Ottery St Mary 'Devon Town' area: Buckerell, Gittisham, Payhembury, Talaton, Feniton, Ottery St Mary, Rockbeare and Whimple.

The definition used will affect the population of the given area. The town contains a population of roughly 5,000 people, the parish is home to around 8,000 people (7,692 in the 2001 census) and the 'Devon Town' contained a population in 2009 of 15,715. For the purposes of this book the wider 'Devon Town' definition will be used.

Until the eighteenth century, Ottery St Mary was predominately a market town, but it also had a cloth industry, highlighted by the opening of a factory in the 1790s, and there was brick manufacturing in the surrounding area. However, with the decline of the cloth industry during the last half of the nineteenth century, the population of the town also decreased from 4,400 in 1851 to 3,400 in 1901.

It is said that to be a true Ottregian you must have at least three generations buried at the church. However, newcomers are welcomed, and today a strong sense of community exists. Events such as Tar Barrels, Carnival, Pixie Day and Coleridge Memorial Day continue each year and attract participation from all sectors of the town population, both long-term residents and new arrivals. The town has created its own sense of identity, and this will hopefully see change occurring at a slow pace.

So what does the future hold for Ottery St Mary? In 2012 the East Devon District Council published its Local Development Plan for 2013–26. This will permit the construction of up to 300 new homes to the south and west of the existing town and around 100 dwellings in the neighbouring settlements. This means that there could be a population increase in the town of around 15 per cent. The town will need to develop to cater for this and has already seen a large supermarket open in 2011. Plans are being drawn up to develop King's School to cater for the predicted increased number of students. However, it is possible that the character of Ottery St Mary will change forever as it develops into a commuter town to meet the needs of Exeter and the industrial development planned outside the nearby new town of Cranbrook, on which work began in 2012.

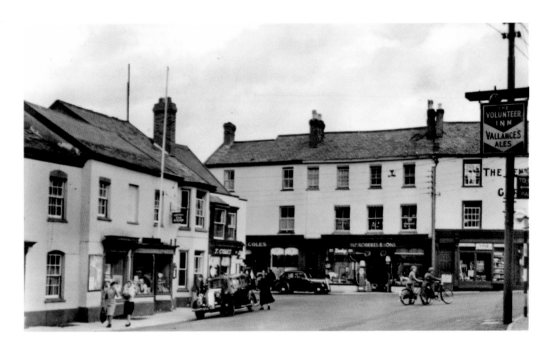

Broad Street, c. 1954
Even though the town has seen many changes, Broad Street still shows signs of continuity. Roberts & Sons and Coles next to the chemists still trade today, as does the Volunteer Inn. The chemist on the left is still a chemist, but part of the Boots chain. However, some shops have gone, like Coles next to Roberts, but this today is the Pine Store, another locally run shop.

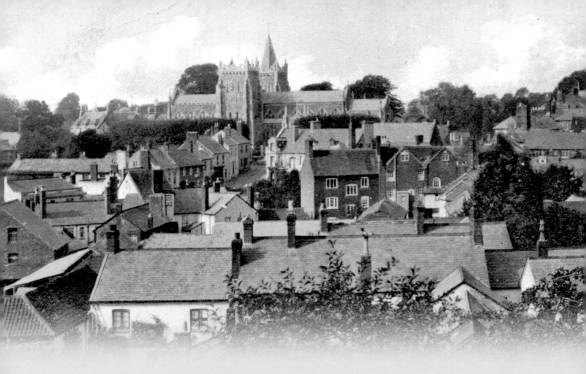

CHAPTER 1

Ottery St Mary Town

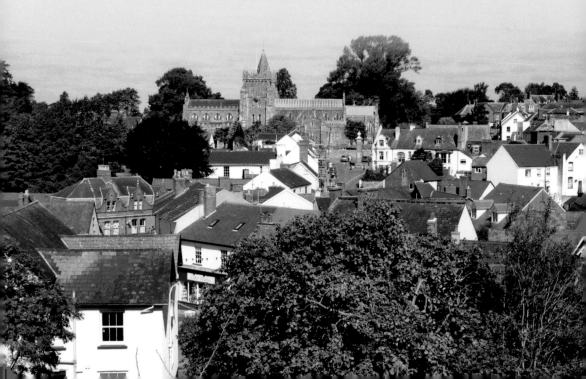

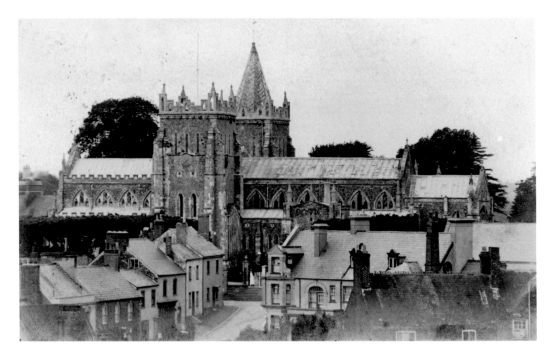

Church Hill and the Parish Church of St Mary, _c._ 1903
Ottery St Mary sits on two main roadways. North to south the road is made up of North Street, Paternoster Row, Corn Hill, Gold Street, Silver Street, and Tip Hill. Running west to east the road is made up of Mill Street, Broad Street, Jesu Street and Yonder Street. It is around these streets that many of the older buildings are found. The church dominates the town and sits at the north end of Silver Street, formerly Church Hill.

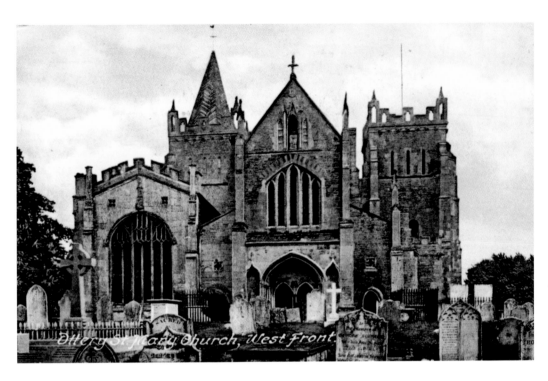

Ottery St Mary Church, West Front, *c.* 1910

The register of Walter de Bronescombe, Bishop of Exeter 1258–80, provides the earliest record of a church in Ottery St Mary. It tells us that he consecrated the church of 'St Marie de Otery' on Thursday 4 December 1259. However, what exists today is mostly the work of John de Grandisson, Bishop of Exeter 1327–69.

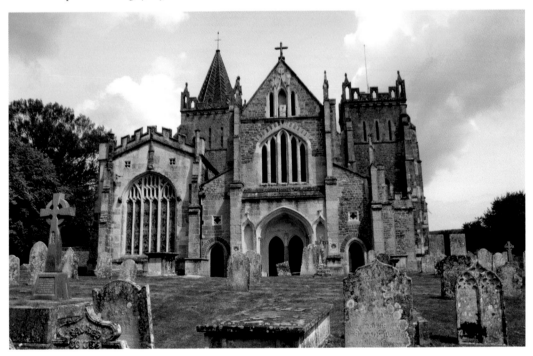

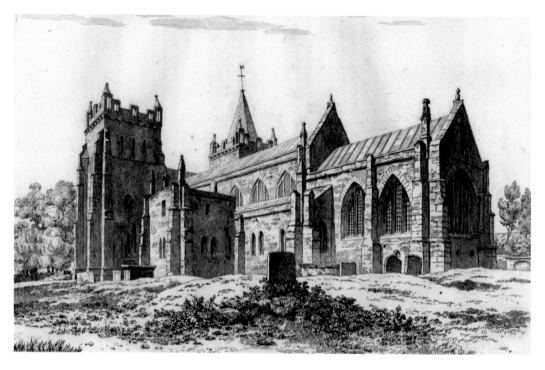

Ottery St Mary Church from the South-East, by Nash in 1822

John de Grandisson, Bishop of Exeter, gained a Royal Licence from Edward III in 1337 to create a collegiate church. The existing church was enlarged and modelled on Exeter Cathedral, including replacing the transepts' roofs with towers. St Mary's and Exeter Cathedral are reputedly the only two churches in England with transepts formed of towers. The new parish church opened in about 1342. Over the last 180 years the graveyard has filled up, with many of the surnames visible on the headstones still local families.

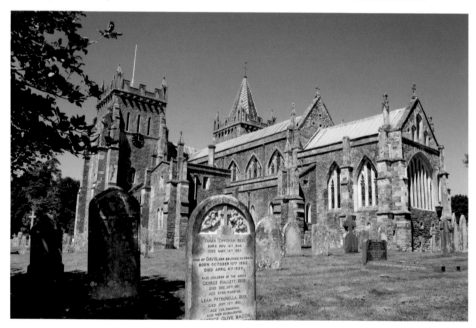

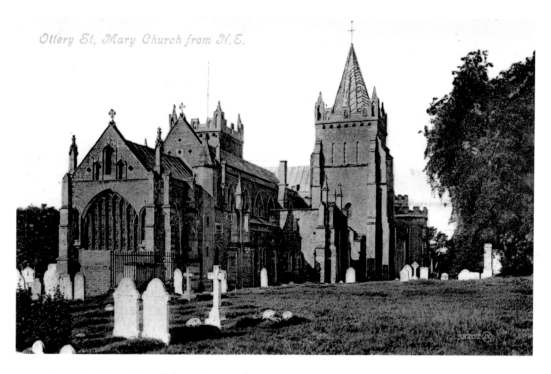

Ottery St Mary Church from the North-East, *c.* 1910
On 24 December 1545 Henry VIII completed the dissolution of the college and granted the people of the town, 'the church, the churchyard, the Bell Tower, and Our Lady's Chapel, The Vestries, the Cloisters and the Chapter House, with their appurtenances'. The north-east corner of the churchyard was not consecrated for burials until 1900. The picture above was taken shortly after permission for burials had been granted, and the 2012 photograph shows the area now nearly full.

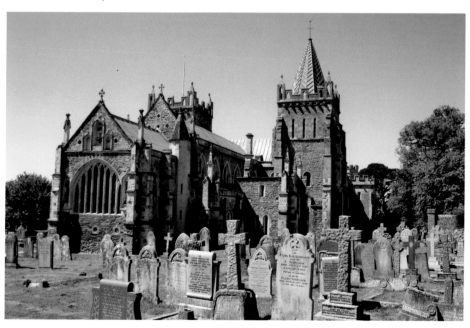

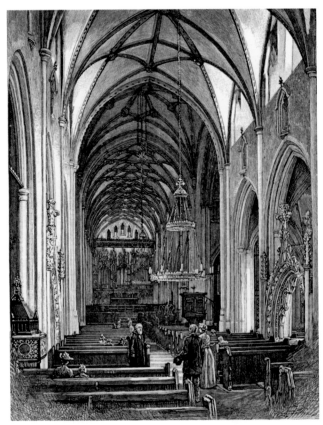

Ottery St Mary Nave Looking East Towards the Chancel, Possibly 1880s
William Butterfield was employed to manage major restoration in 1849. He opened up the church into a single area for worship, including the removal of the choir screen that divided the chancel from the nave and the lowering of the floor in the transepts and west part of the chancel to the level of the nave. In 1878 the walls in the south transept were tiled in mosaics, and in 1919 wall plaster throughout the church was removed to reveal the original stonework.

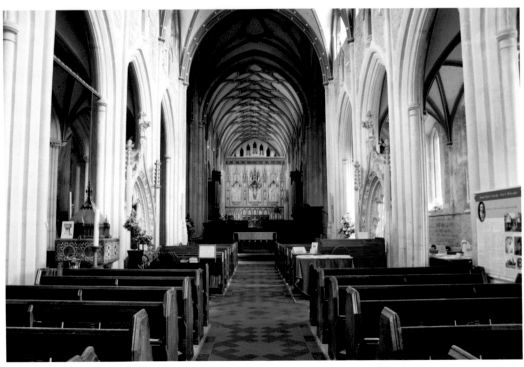

Dorset Aisle, *c.* 1910

Around 1520, the fan-vaulted Dorset Aisle was constructed. It is named after Lady Cicely Bonville, who married Henry Grey, Marquis of Dorset, in 1476 and became the Marchioness of Dorset. In 1494 she inherited Knightstone in Ottery St Mary and helped fund the aisle's construction. The pier-capitals are exquisitely decorated with stone carving, including representations of an owl (emblem of Hugh Oldham, Bishop of Exeter 1504–19) and an elephant's head.

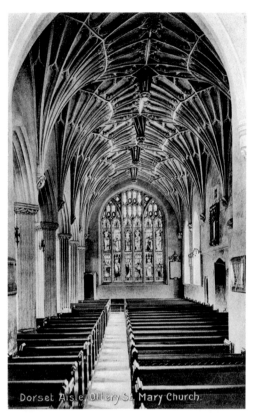

Dorset Aisle, Ottery St. Mary Church.

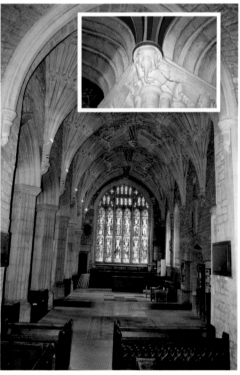

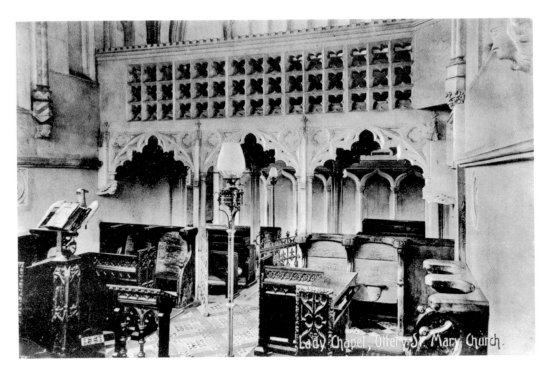

The Lady Chapel, *c.* 1910

The central bosses in the Lady Chapel represent the Blessed Virgin and Child and Our Lord enthroned in Glory. The tiled alter screen was added in 1881 and depicts the annunciation. On the south wall is a corbel-head of Bishop Grandisson wearing a mitre, and on the opposite wall is the head of his sister, Katherine (1303–49). It is claimed that Edward III was entranced by her beauty and because of that founded the Order of the Garter.

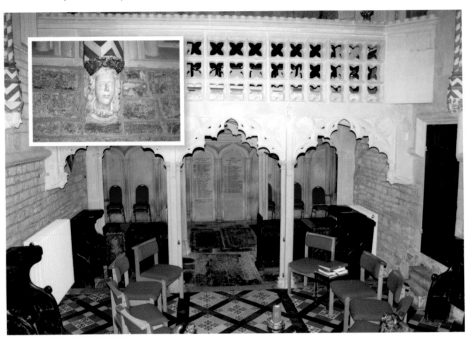

The Grandisson Clock in the Church, c. 1910

Bishop Grandisson placed the clock in the bell tower in around 1340 to regulate 'the time of fast and festival, prayer and vigil, solemn chant and stately ceremonial during the centuries of time'. It illustrates the beliefs of the time that the earth was at the centre of the universe. The outer circle shows the twenty-four hours of the day, with the hour of the day or night indicated by the golden sun rotating around the earth. The inner circle has thirty discs marked with Arabic numbers, representing the synodic month (twenty-nine days, twelve hours, forty-four minutes and three seconds) and a star moves around to show the age of the moon. Within the circle an orb revolves on its own axis to show the phase of the moon and travels round the circle once every twenty-four hours. The clock was restored in 1907 by Mr Hall, who had found it dismantled.

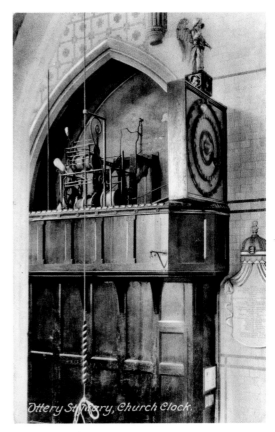

Ottery St Mary, Church Clock.

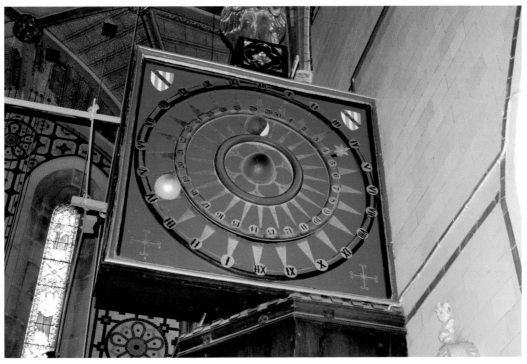

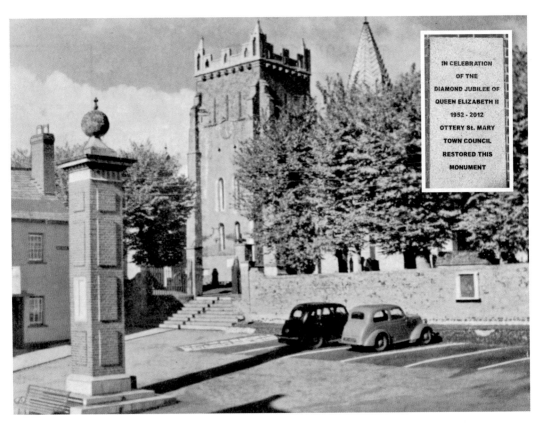

IN CELEBRATION
OF THE
DIAMOND JUBILEE OF
QUEEN ELIZABETH II
1952 - 2012
OTTERY St. MARY
TOWN COUNCIL
RESTORED THIS
MONUMENT

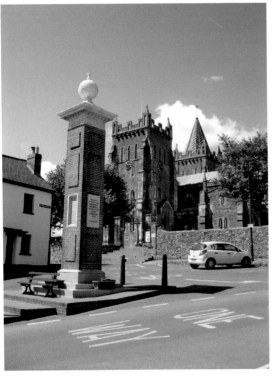

Jubilee Memorial, 1950s

The memorial was erected in 1887 to mark Queen Victoria's sixtieth year on the throne. There was a campaign to have the monument dismantled in the 1960s due to a fear that it might collapse; fortunately it failed. In May 2012 the memorial was updated with the addition of two new plaques, one in English and one in Latin, marking the sixtieth year of the reign of Queen Elizabeth II.

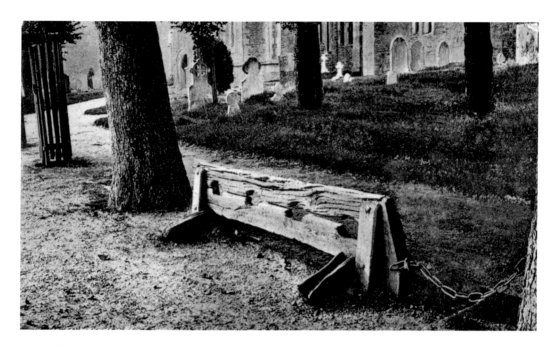

The Town Stocks, *c.* 1910

The records suggest that the stocks were last used as a punishment in 1863. They had been originally located where the jubilee memorial monument now stands, but they were moved into the churchyard following the memorial's construction in 1887. At some point the old stocks seem to have been repaired (or replaced?), relocated nearer to the entrance of the cemetery and given a wooden roof for protection.

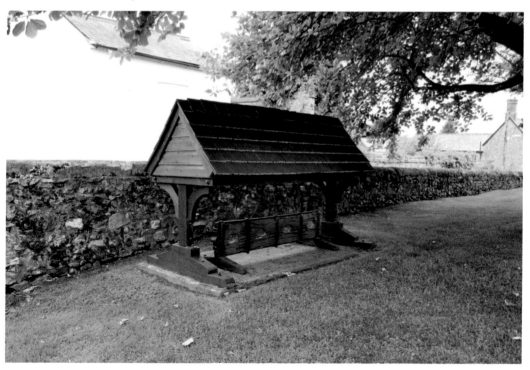

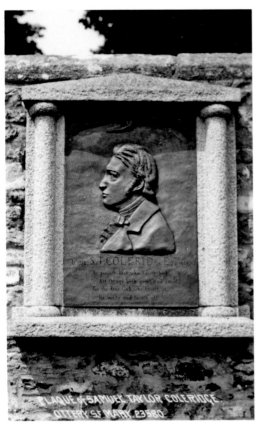

Samuel Taylor Coleridge Memorials

The Reverend John Coleridge came to Ottery St Mary in 1760 as vicar and master of the King's School, posts he held until his death in 1781. His thirteenth child was the poet and philosopher Samuel Taylor Coleridge, born 21 October 1772. Celebrations of Samuel Taylor Coleridge's life (1772–1834) and work can be found throughout the town: the official memorial plaque installed in the church wall in 1931; the Heritage Society plaque near to his birthplace; the 2012 installation of carved kerb stones at Land of Canaan, citing one of his best-known poems, 'Kubla Khan'; the Coleridge footbridge erected in 2012; and the Coleridge Medical Centre, Coleridge pre-school and street names.

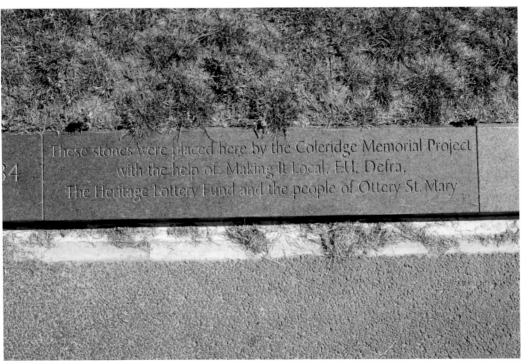

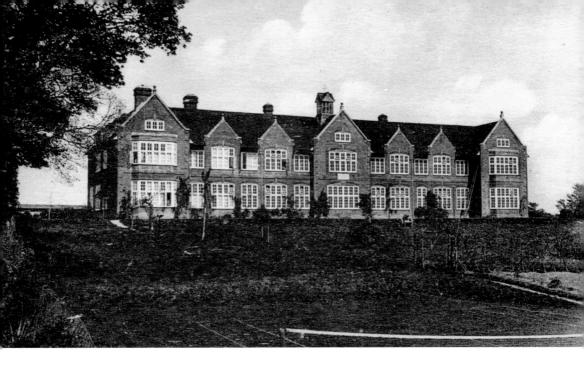

The King's Grammar School, _c._ 1920

In 1545, when Henry VIII had the collegiate closed, a free grammar school was established and the town was instructed to pay a schoolmaster £10 a year to 'instruct the youth of the parish in the Kynges Newe Grammar Scole of Seynt Marie Oterey'. It moved to its present site in 1912, became a comprehensive school in 1982 and an academy school in 2011. Further expansion of the school is planned to meet the growing demand.

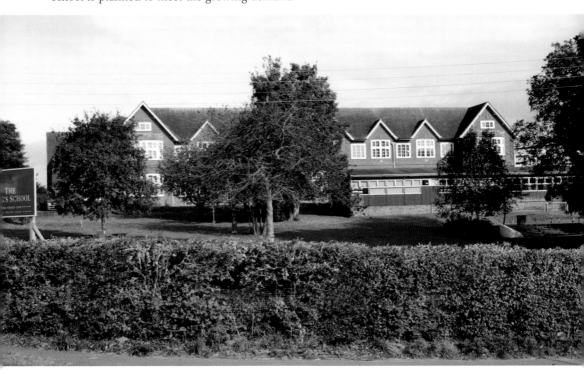

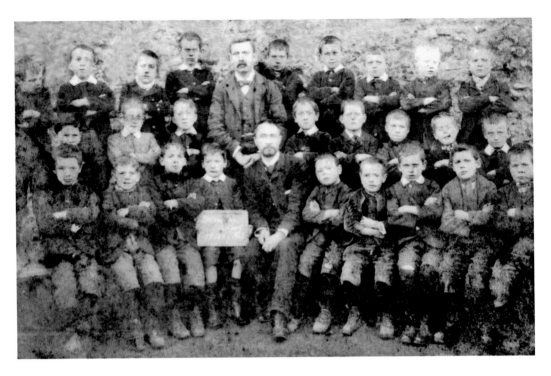

Old Boys School Group, 1895
In August 2012, the Ottery St Mary Heritage Society (formed in 1999) held an exhibition on the history of the town in the Old Boy School. Former Old Boys School pupil and local historian Peter Harris (standing on Mayor Dobson's right) had an area to display his collection of postcards, some of which have been used in this book.

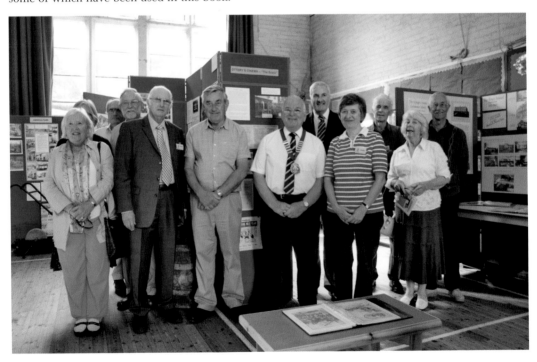

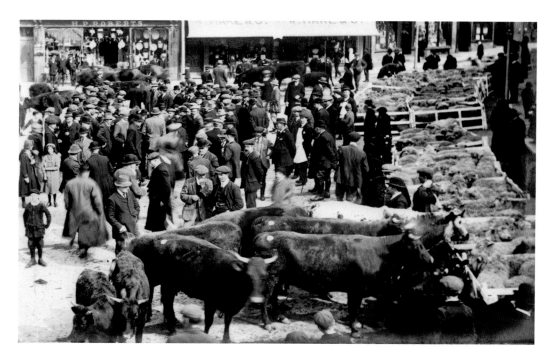

Market in Broad Street, 1923

The twice-weekly market started in 1227, and later there was a monthly livestock market and three annual fayres. The market ceased in the 1950s. Today there are some small farmers' markets but most produce is now purchased from shops. The opening of Sainsbury's in 2011 has been greeted with mixed feelings. However, the supermarket will allow the town to grow and meet the plans being proposed in the Local Development Plan for 2013–26.

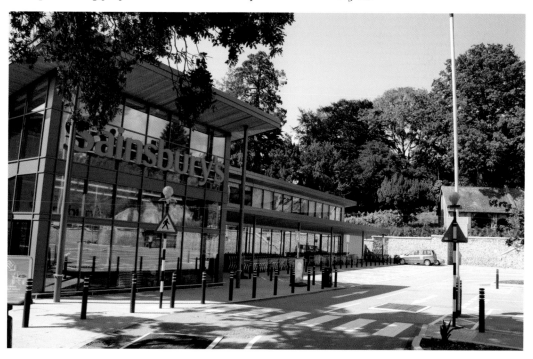

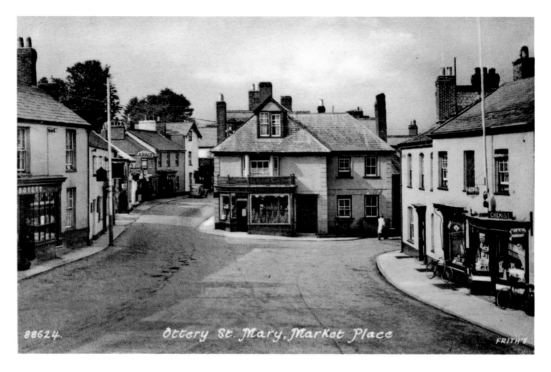

Broad Street, 1930s, Looking West
This has been the heart of Ottery St Mary for centuries. Formerly the site of the old market place, today the area is used as the centre for community events, with large crowds gathering here to watch some of the Tar Barrels, the Carnival and the release of the bellringers during Pixie Day.

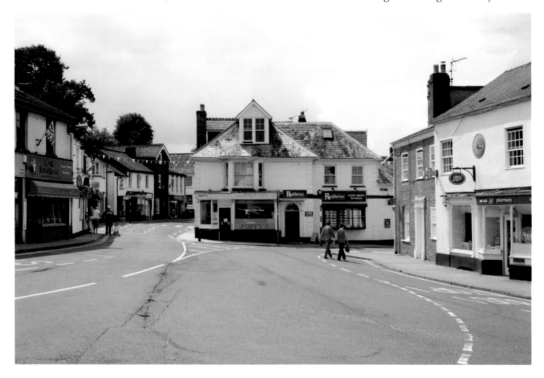

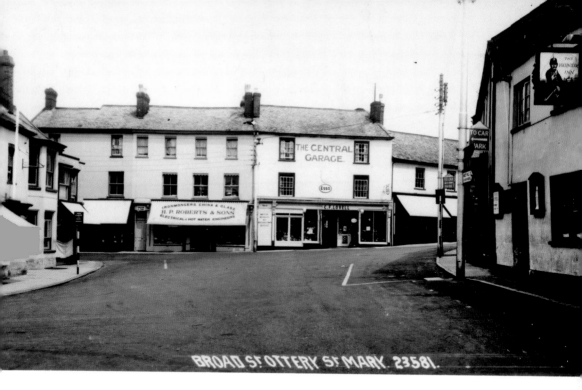

Broad Street, *c.* 1960, Looking East
In the 1970s the Central Garage relocated to behind these shops with an entrance on Brook Street.
Today the garage is Lovell's and the old Central Garage now houses Hall & Scott estate agents.

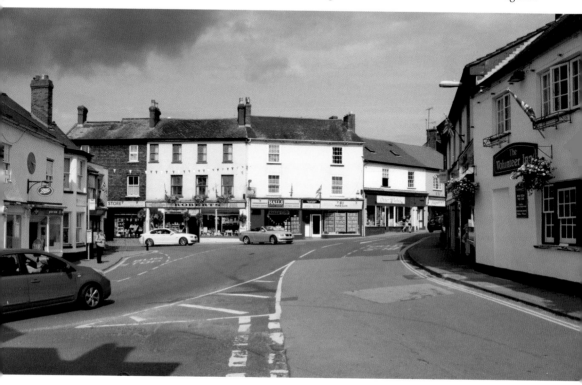

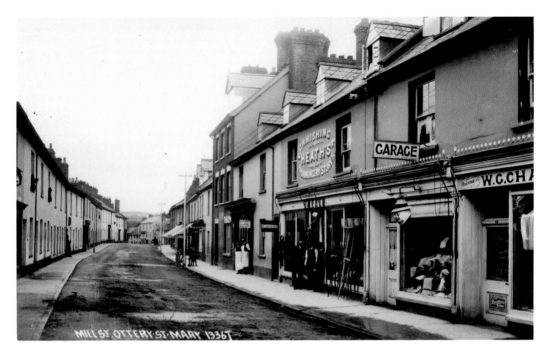

Mill Street, c. 1910

Along the main roads one can still find the traditional small town shops, often family-run. The baker's, butcher's, jeweller's, bookshop, hairdresser's and post office still fill these streets in 2012. However, the town centre has gone through periods of growth and decline, and like many small towns the downturn in the economy and internet shopping boom meant that many empty shopfronts appeared in 2011 and 2012.

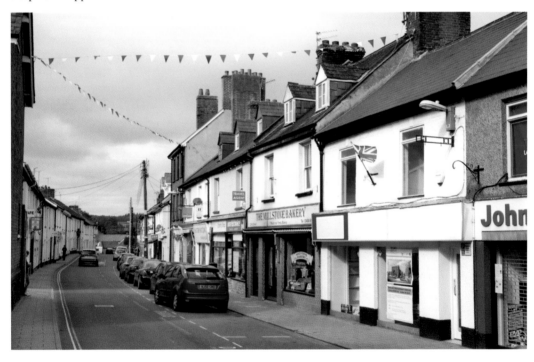

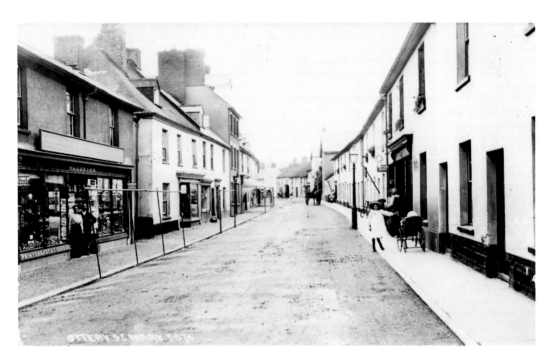

Mill Street, c. 1904

In the above picture, the metal stands on the left side were used to hold the awnings of the shops. The shops have been a central part of local life and Mill Street is usually a hive of activity. Many of the shops enter the numerous window display competitions, and a regular winner is the Millstone Bakery, here showing their display to mark the sixtieth anniversary of the reign of Queen Elizabeth II in June 2012.

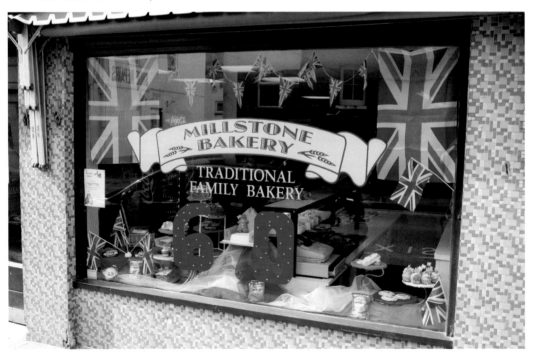

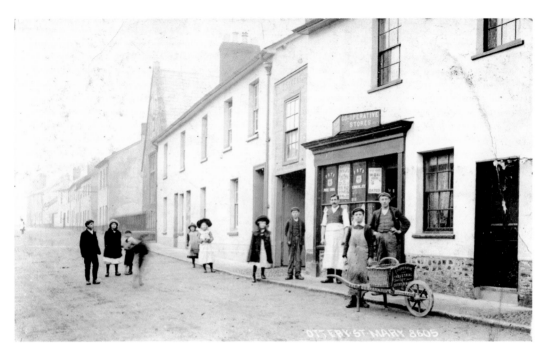

Yonder Street, *c.* 1907

The Co-operative store has been a fixture on Yonder Street for over a century. Delivery vehicles have changed dramatically since the early days, with the 1907 photograph showing the delivery boy with the wheelbarrow ready for his rounds.

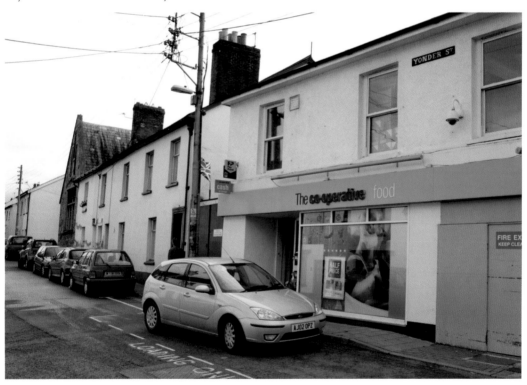

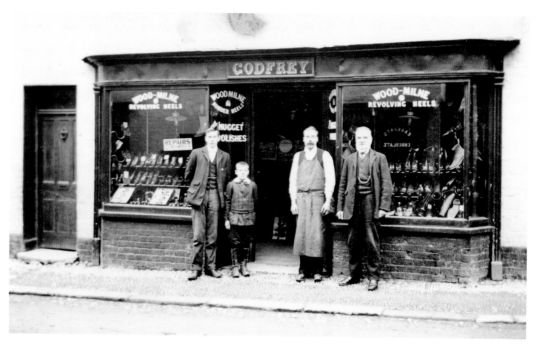

Godfrey's Shoe Shop, Silver Street, 1908

Pictured outside the footwear specialist shop are Walter Godfrey, Kenneth George Godfrey, John Henry Godfrey and George Godfrey. Today the shop is the Seasons restaurant, owned by Martin Patterson, who is pictured outside in 2012.

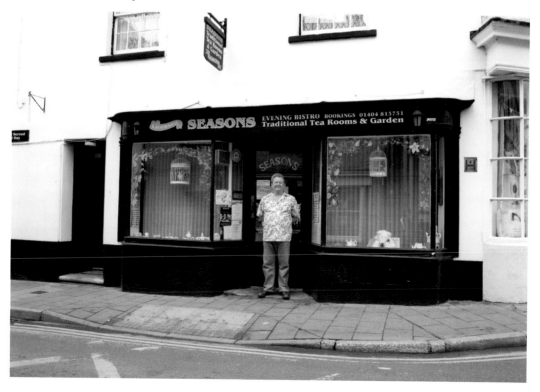

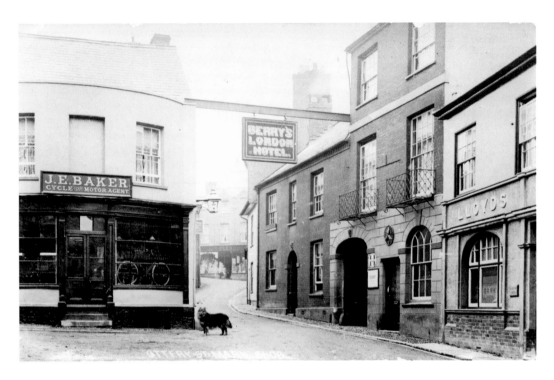

Looking up Gold Street, *c*. 1910

The London Inn and Lloyds bank still occupy the same buildings over a century later. The building occupied by J. E. Baker, cycle and motor agent, had formerly been Manley News. It was later demolished, becoming part of the roadway, and the area behind became the National Westminster bank.

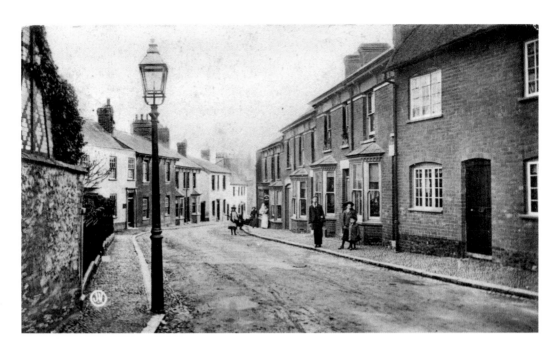

Paternoster Row, *c.* 1909

Paternoster, meaning the 'Lord's Prayer', runs to the north-east of the church. The run of houses on the right, with people standing outside, was rebuilt in 1903 after a fire in 1899, which had probably started in the bakehouse behind the Hine's bakery (No. 11). Some of the Hine family are standing outside their shop. Below, some of the modern residents stand outside the same houses in 2012.

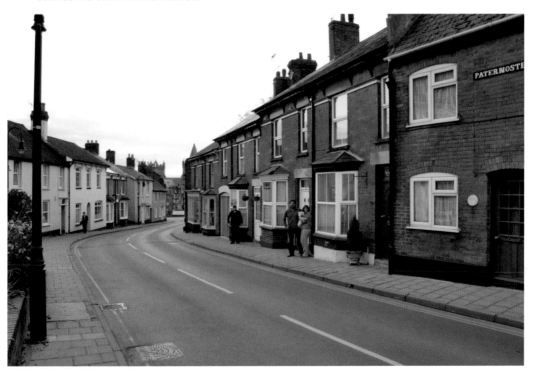

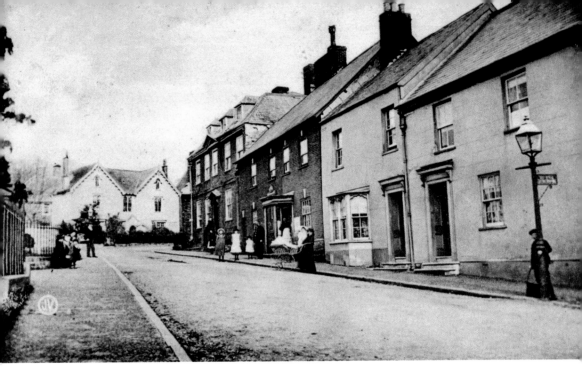

Cornhill 1905, Showing the Old Police Station

The covered doorway is the old police station, which in 1949 moved into the neighbouring property, the Priory, now a care home, where it remained until 1974. In the historic part of town the house owners take pride in keeping the town looking smart, as shown by local painters in 2012.

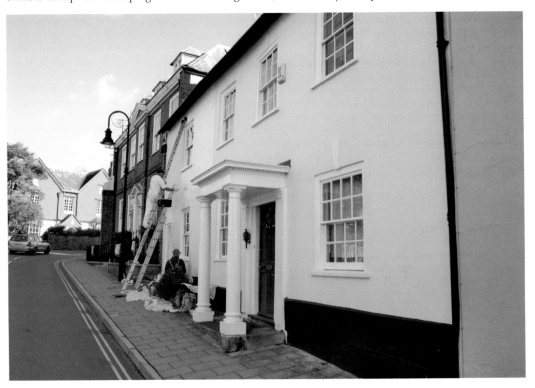

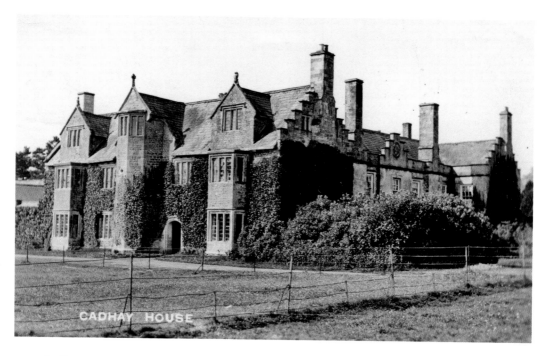

Cadhay House *c.* 1905

Parts of the original house, built by the De Cadehayes during the reign of Edward I (1272–1307), were incorporated into John Haydon's new house, *c.* 1550. Haydon, a governor of the church of St Mary, used dressed stone from the recently closed college buildings. By the nineteenth century, the building was rented out, and numerous farm outbuildings and cottages were erected near or attached to the house. When Mr Dampier Whetham purchased the house in 1910, some of these cottages and stables were demolished to restore the gardens.

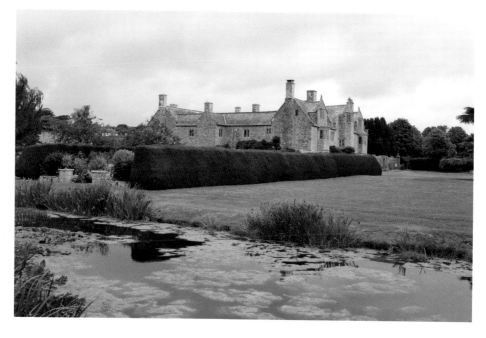

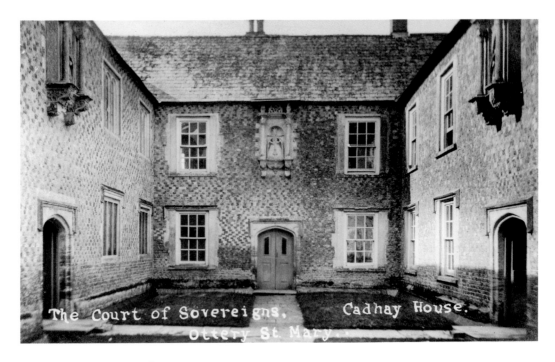

Court of Sovereigns, Cadhay, c. 1920
Robert Haydon took over ownership of Cadhay in 1587 and is responsible for the wall treatment in the central courtyard, which has stone carvings of the Tudor kings and queens above each door: Henry VIII, Edward VI, Mary I and Elizabeth I. Made in about 1617 – the date appears under the statue of Elizabeth – they give the courtyard its name.

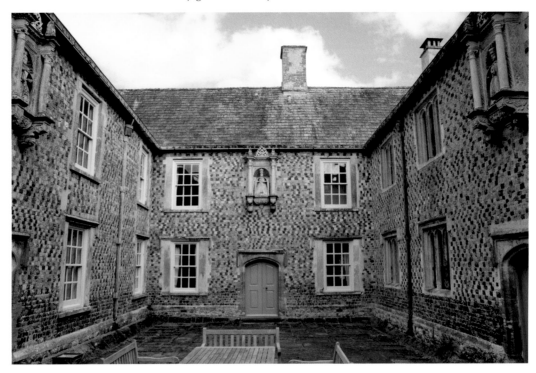

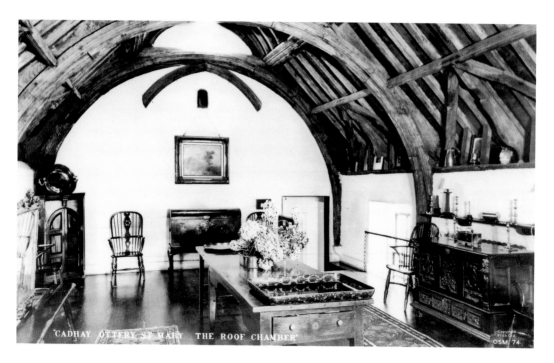

The Roof Chamber, Cadhay, c. 1920

The timber roof was part of John Haydon's great hall. Originally it was believed that the timbers were salvaged from a nearby building and adapted to fit this space, but recent research suggests the roof was built specifically for Cadhay. William Peere Williams, who purchased the house in 1737, inserted a first floor in the great hall, and eventually the space was further divided and became accommodation for the farm labourers. The room is now popular for weddings.

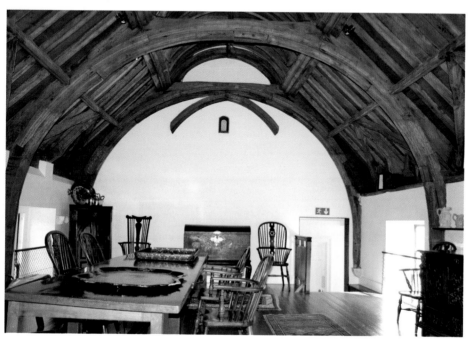

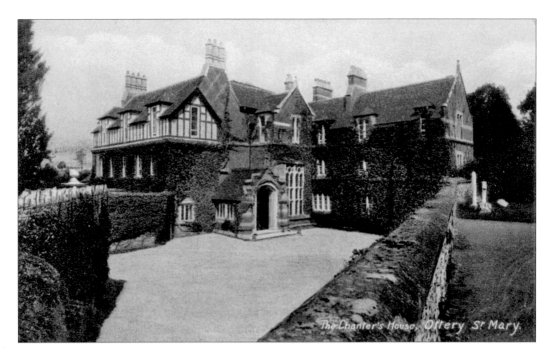

Chanter's House, c. 1910

Little remains of the original fourteenth-century structure, as it was largely rebuilt in 1880–83 by William Butterfield for his friend the 1st Baron Coleridge, Lord Chief Justice of England. This house was used by the Parliamentary forces at the end of the Civil War, and in the dining room a carved inscription records that Oliver Cromwell and Sir Thomas Fairfax were present in the house in 1645. In 2006 the 5th Baron Coleridge was forced to sell the house and many of its contents.

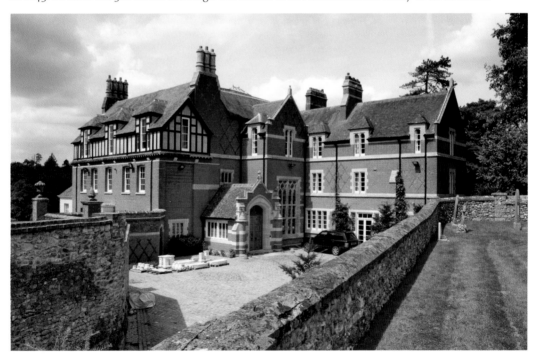

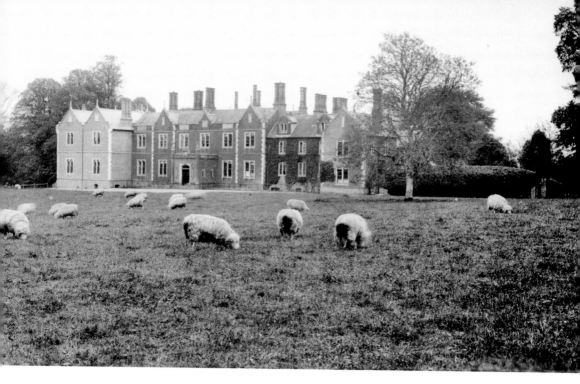

Salston Manor, *c.* 1920 and 1960s

There has been a house on this site from at least 1765. William Hart Coleridge, nephew of Samuel Taylor Coleridge, was the Bishop of Barbados and the Leeward Islands, but when he fell ill in 1841 he was forced to retire and settled at Salston House, where he died on 21 December 1849. During the 1960s the house was converted into a hotel, which closed in 2008. Today the house is empty and awaiting redevelopment.

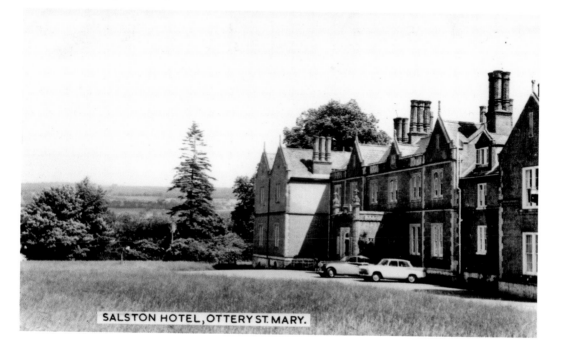

SALSTON HOTEL, OTTERY ST. MARY.

33

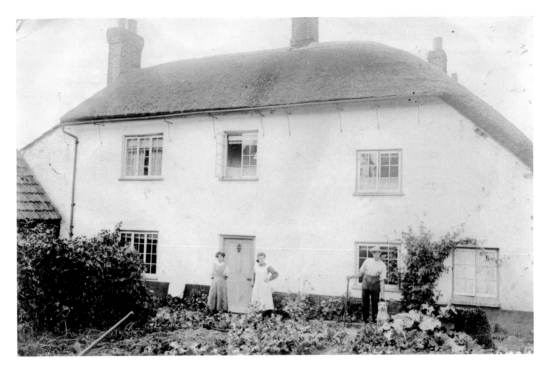

Unidentified Cottage, Postmarked 17 August 1912

This photographic postcard was taken to show the family outside their home, the equivalent today of sending a picture attachment to an email. The handwritten message on the back reads 'Dear Bess, Sorry, Dorothy was asleep when this was taken. Travelling around. What beautiful weather. When are you coming down. Love to all, Emily.' Is Emily in the photograph? There are still many beautiful old homes in the area, like the one below, but with modern development the town has expanded with many post-1970s houses.

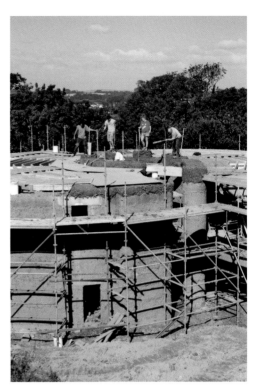

Kevin McCabe's Company Constructing a Cob House at Keppel Gate, 2012
A traditional local building method is cob construction. Clay is mixed with straw, water and sometimes sand or flint. The mixture is then stamped together, and each level can take two weeks to dry before it can be built onto. As the walls rise they are trimmed to keep uniform thickness with openings left for doors and windows. This construction style all but disappeared until 1994 when local Kevin McCabe built the first new cob house in seventy years. Below is Budeaux House, reputedly the oldest cob house in Ottery St Mary, in 1984, before its conversion from a farm into a private house. Inset, Kevin McCabe is seen using a beater.

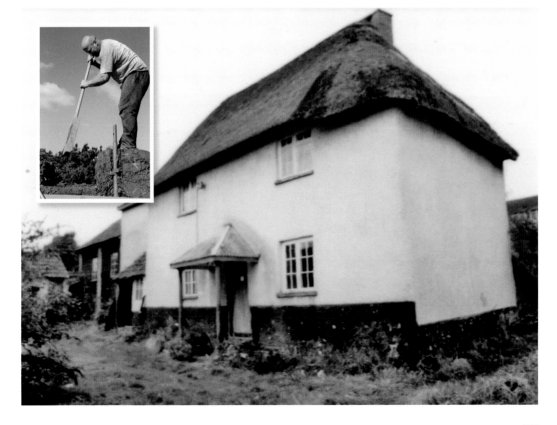

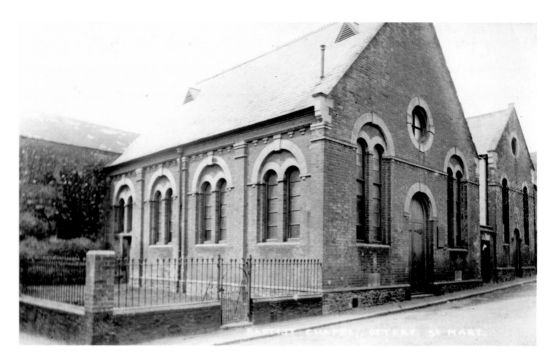

Baptist Church, Batts Lane, c. 1910

The Baptist church on Batts Lane opened in 1878 and closed in 1936. From the 1940s it was the home of the fire station until the present one on Cannan Way opened. On 5 November 2009 the roof burnt down; the fire was unrelated to Tar Barrels, which was taking place that night. Today the southern half of the building awaits redevelopment, while the northern part has been converted into housing.

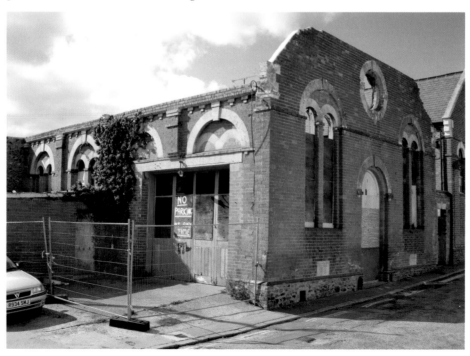

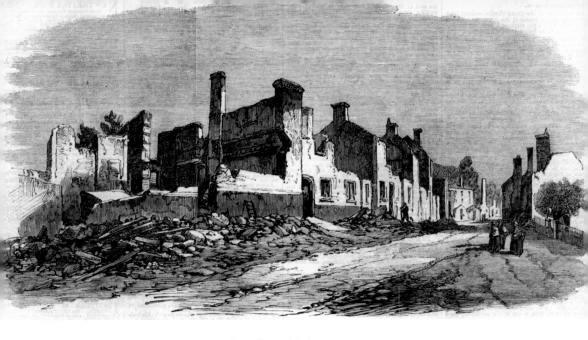

Yonder Street and Jesu Street After the 1866 Fire

Like many small towns, Ottery St Mary has a history of devastating fires. Unfortunately, lessons had not been learnt after the fire in 1767, which started in the cooper's shop and burnt down forty to fifty houses. With few new precautions put in place, there was some inevitability about the destruction caused by the 1866 fire.

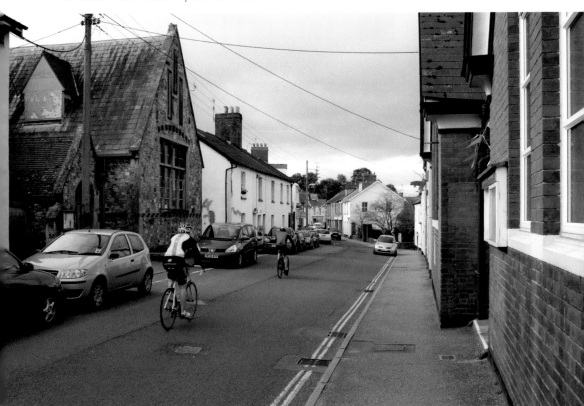

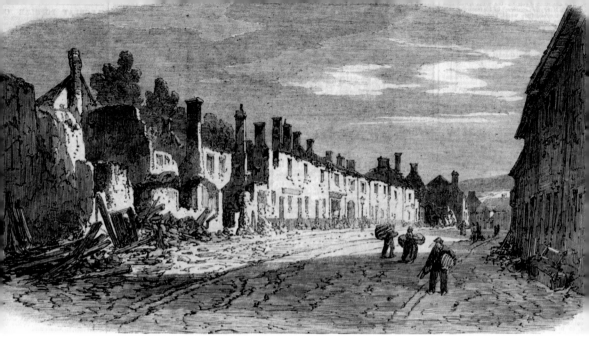

Mill Street After the 1866 Fire

The 1866 fire was the worst to hit the town. It saw the destruction of around 100 houses, nearly a quarter of the town, and left around 500 people homeless. The fire spread quickly due to the building material used – wooden rafters and thatch for roofs.

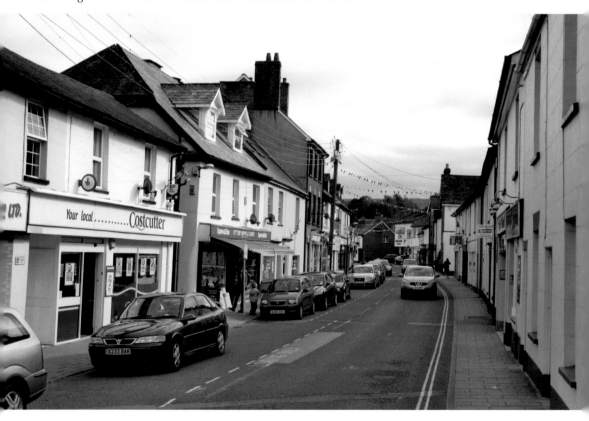

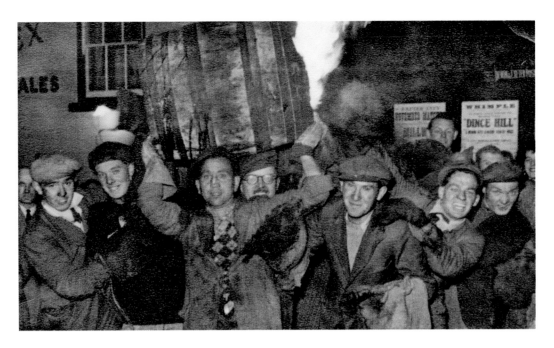

Jerry Totterdale Carrying a Tar Barrel in the 1950s

Some fires are planned. The annual Tar Barrels, held on 5 November, sees teams carrying burning barrels. The full reasons have been lost in antiquity; maybe barrels were lit to scare away rats at harvest time, maybe to ward off evil spirits, or as a task to prove 'manliness' – nobody knows. Each inn sponsored a barrel, and even though many have closed, teams still bear the old pub names. People attend at their own risk, as the barrels are run into the gathered onlookers, shown below in 2012.

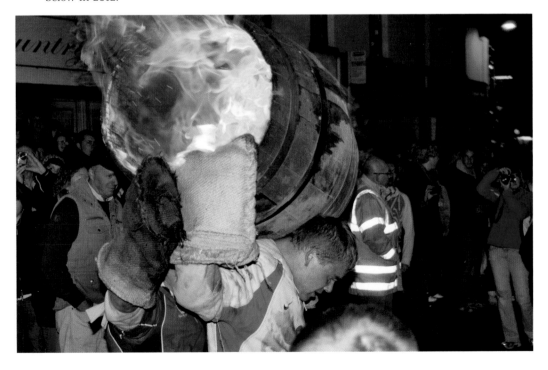

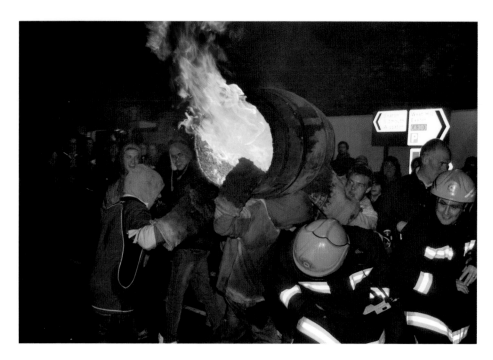

Tar Barrels on Broad Street in 2012, and Below in Yonder Street in the 1980s
As one can imagine, Tar Barrels evening can have some dangers, and as the photograph above shows, even the fire officers on duty sometimes have to take cover. In 2009 the event was almost brought an end when an aerosol can was thrown into a barrel and exploded, leaving twelve spectators requiring treatment. A massive increase in the insurance bill for 2010 put it at risk, but local support raised the funds and the tradition continues.

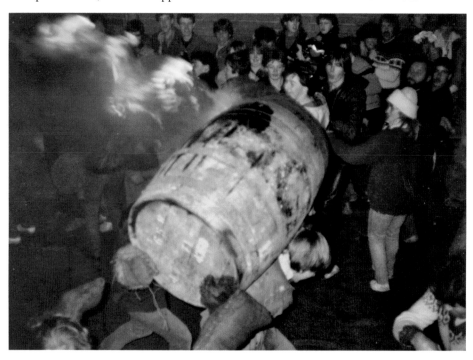

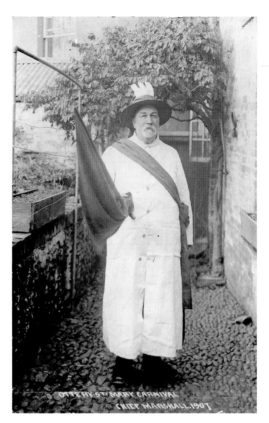

Mr A. Cripps, Chief Marshall at the 1907 Carnival

Early twentieth-century records show that the carnival, started in the 1890s, was held on 5 November, and the evening saw a procession of horse-drawn floats followed by the rolling of tar barrels. Tar Barrels and the Carnival continued to be held on the same evening for many years. However, in recent years, with increasing insurance premiums, it was necessary to make the two events separate. Today the carnival is still lead by a burning barrel to show this link, as seen below in 2011. It is unclear when the act of rolling barrels changed into carrying the barrels.

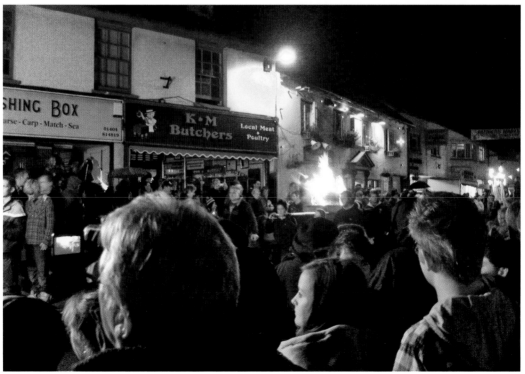

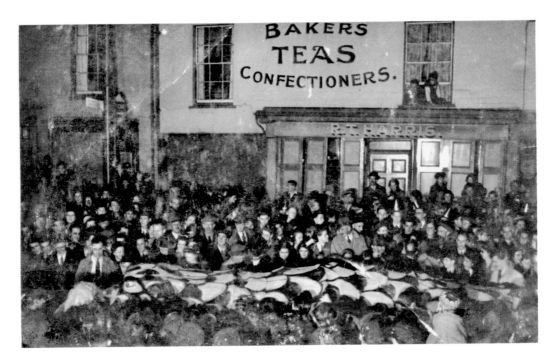

Dragon in the Carnival, 1947

Like most small towns in Devon, Ottery St Mary has an annual carnival. Today it is the weekend preceding the Tar Barrels. Floats created by neighbouring towns in East Devon take part in each other's carnivals, which means carnivals run in the East Devon area for a month or more. The Bump in the Night Carnival float (*below*) was created by Sidvale Carnival Committee and was voted the overall winner in the 2012 Ottery St Mary Carnival.

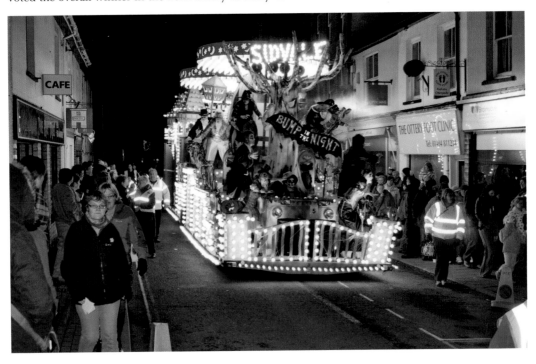

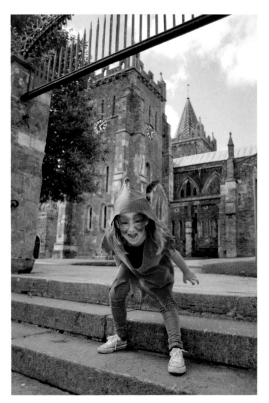

Rowen Nickels Taking Part in Pixie Day, June 2012

It is said that pixies once lived in Ottery St Mary and were in dispute with the humans. Pixies could not stand the sound of bells, and with plans to erect bells in the church in 1454 the pixies acted. They entranced the monks bringing the bells from Wales and led them to the coast. One monk stubbed his toe (or trod on a thistle, depending on which story you hear), which woke him, and he saved the monks and the bell. With the installation of the bell in the church, the pixies were banished to the Pixie Parlour, a cave in the banks of the River Otter a mile outside town. Once a year the pixies have enough strength to enter the town to stop the sound of the bells by kidnapping the bellringers. Below is Pixie Day in the 1950s.

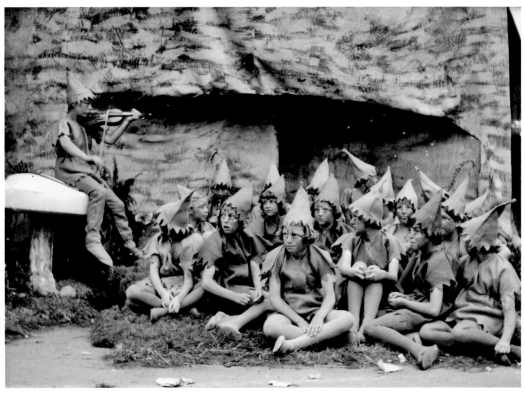

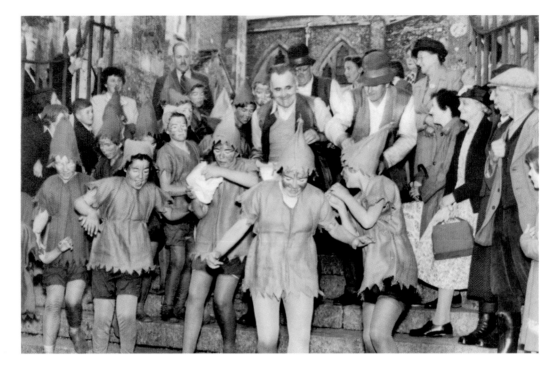

Capturing the Bellringers, Pixie Day, 1950s

In the 1950s, Pixie Day was started to commemorate the banishing of the pixies. The day raises funds for local Scout and Girl Guide groups and members from the Cubs and Brownies make up the pixie numbers. They kidnap the bellringers from the church and lead them to their 'cave' in the centre of town. The townsfolk gather round and free the ringers, who then drive the pixies out of town, as shown below on Pixie Day 2012.

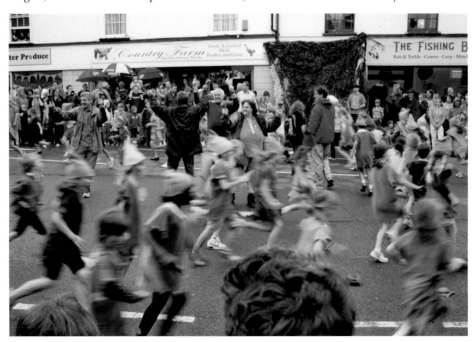

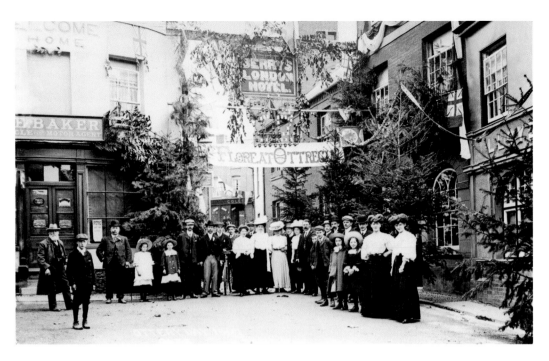

Ottery Day Group on Gold Street (Above) and Silver Street (Below), 1907

In 1898 six men from Ottery St Mary living in London formed the Old Ottregian Society. In 1907 they held their first annual day trip to Ottery St Mary, which continued into the 1930s. On Whit Monday the town welcomed home those now living in London with gusto, decorating the town. Decoration by the London Hotel in Gold Street is shown above (*see p. 36 for undecorated view*). The banner carries the Society motto, *Floreat Ottregia*, meaning 'may Ottery flourish'. Below, the group is standing by Godfrey's shoe shop (*see p. 25*). The Society was formally disbanded in 1948.

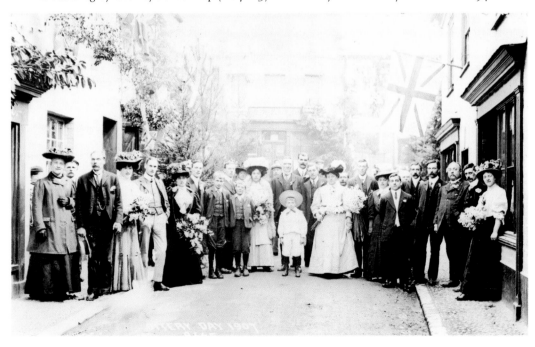

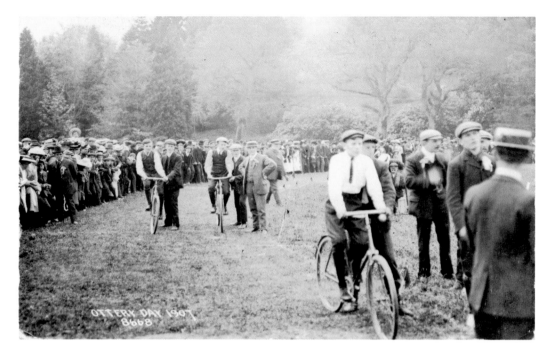

Slow Bike Race During Ottery Day, 1907
Residents through the ages have taken part in community events for fun and to raise funds for charity. Above was one of the annual Ottery Days. Below is the Ottery Family Fun Olympics on 8 July 2012, organised by the Otter Valley Rotary to raise funds for the British Heart Foundation. The Dirty Old Ladies (Paul Floyd, Bill Hayes, Paul Swingler, Scott Gibbins and Alison Gannon) were runners up to the Young Farmers in the Bed Grand Prix.

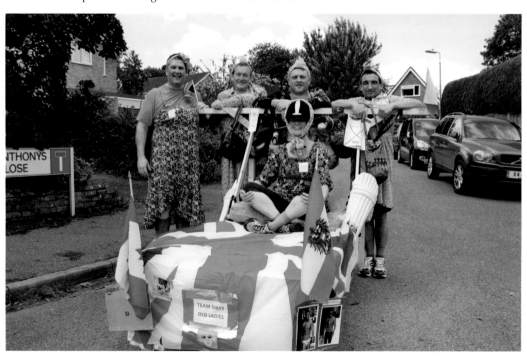

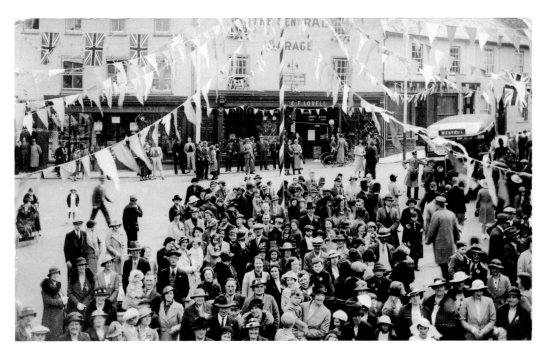

Broad Street With Crowds Celebrating George VI Coronation, 12 May 1937
The town has celebrated royal events with gusto. In 2012 a jubilee event was held on the Land of Canaan and many of the shops decorated their windows. The shopfronts decorated for Queen Elizabeth II Golden Jubilee celebrations in 2012 are the same shopfronts shown on the left of the 1937 picture.

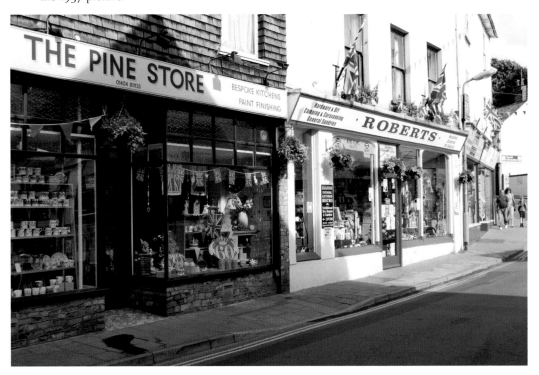

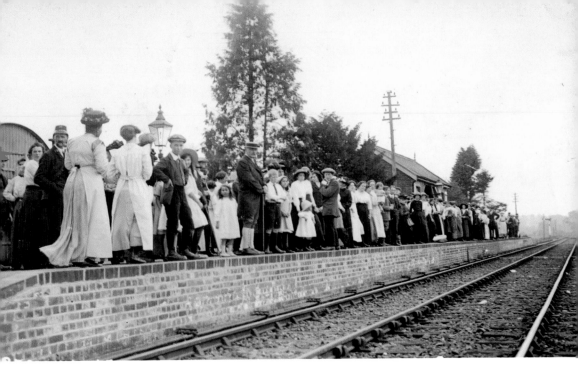

Recruits Leaving Ottery St Mary Station, 1 September 1914
Eighty-seven Ottery St Mary men paid the ultimate price, and it is possible that some of the young men shown in the picture, surrounded by family and friends, have their names on the war memorial in the parish church, shown below.

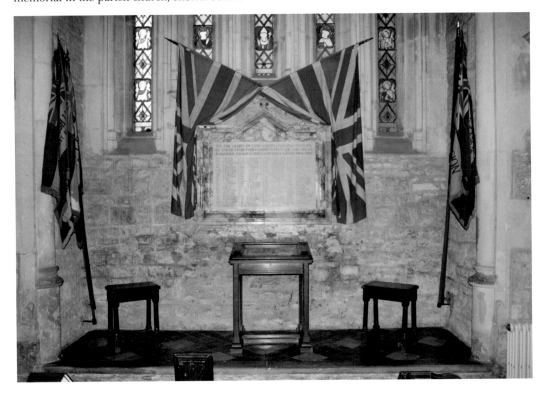

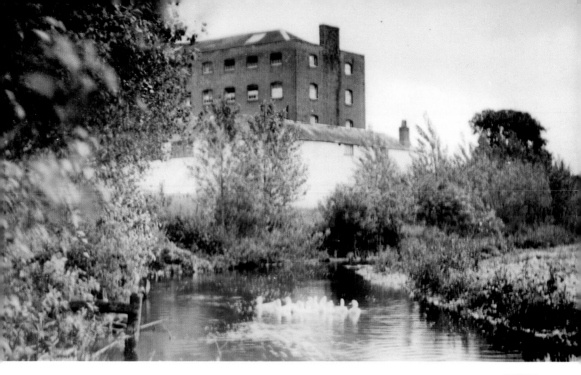

The Old Factory After Being Used to Billet Troops, c. 1950
During the Second World War the empty factory was requisitioned to billet troops. Eighteen men from the town of Ottery St Mary were killed on active service during the war. Their names are immortalised in the memorial inside the church and their sacrifice commemorated by the war memorial outside Ottery St Mary church, shown on 11 November 2012.

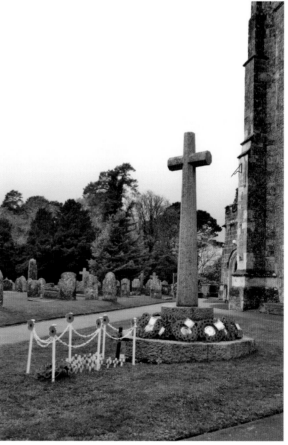

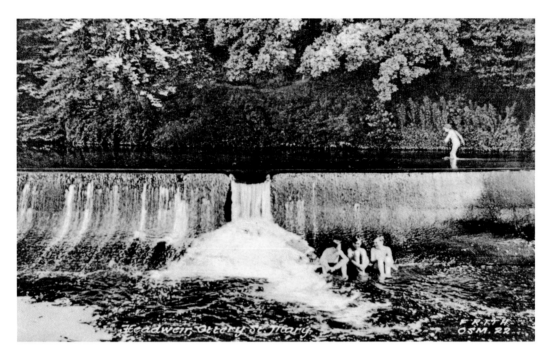

Children Playing at the Head Weir on the River Otter, 1930s
The weir is still used today by children to play. In the 1930s the area above the weir was the location for the Ottery St Mary Swimming Club, until it closed due to concerns about polluted water. Some of the water above the weir is diverted and becomes the mill stream, taking water to the Ottery St Mary mill and factory and ending at the Tumbling Weir.

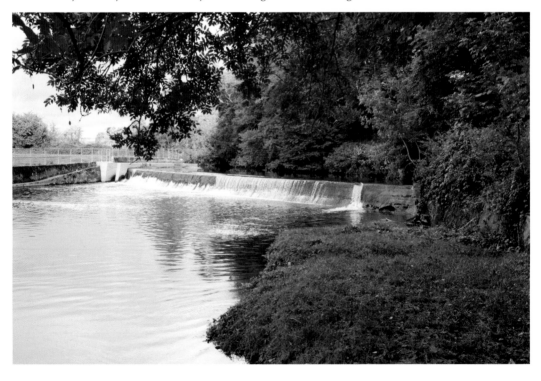

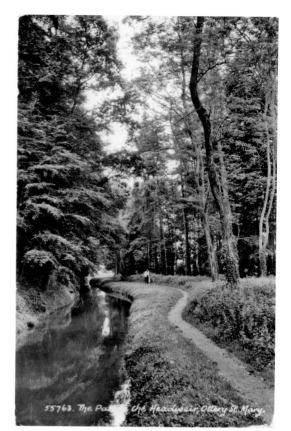

Path to the Head Weir, *c.* 1950, Looking South
This path follows the mill stream from near to the Sitting Bridge to the Head Weir. It is popular today with walkers and leads to an area used today by young cyclists to practice jumps in-between the trees.

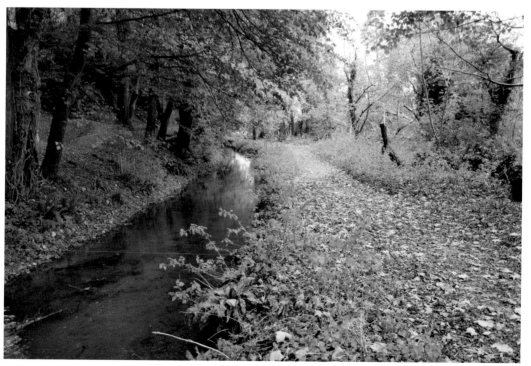

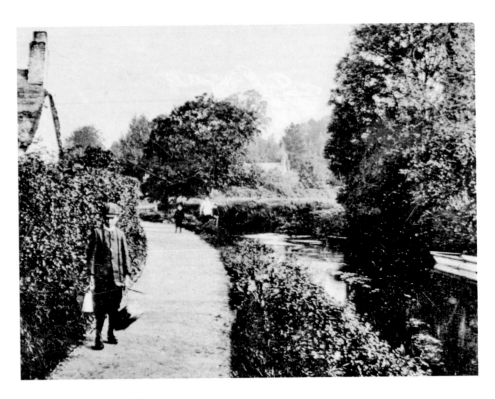

The Path Along the Mill Stream, c. 1912

The mill stream has its origins in Anglo Saxon times. Also known as the leat, it took water from the River Otter at the weir head about 1½ mile from the mills, as at this point the river drops in height. The seventeenth-century cottage on the left is today the Tumbling Weir Hotel.

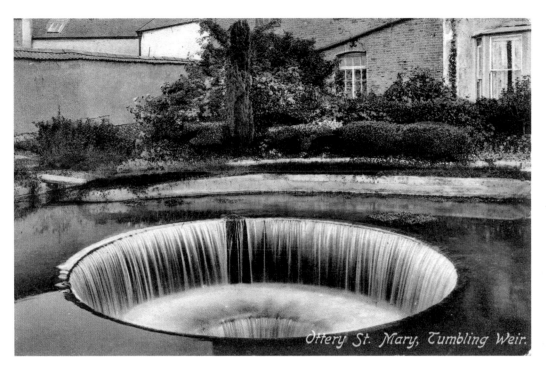

Ottery St. Mary, Tumbling Weir.

The Tumbling Weir, *c.* 1909
This unusual weir, a circular cast-iron structure, 15 feet in diameter, was constructed in about 1790 to take excess water from the mill stream back to the River Otter. At this time the mill pond was raised in height to provide sufficient head for the 12-foot wheel in the new flour mill and the 18-foot wheel in the new factory. This view is looking towards the old corn mill. As the picture from 2011 shows, the well-kept garden has gone, sometimes the lip of the weir is strewn with litter, and the mill is boarded up awaiting development.

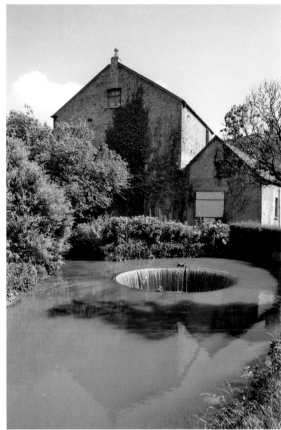

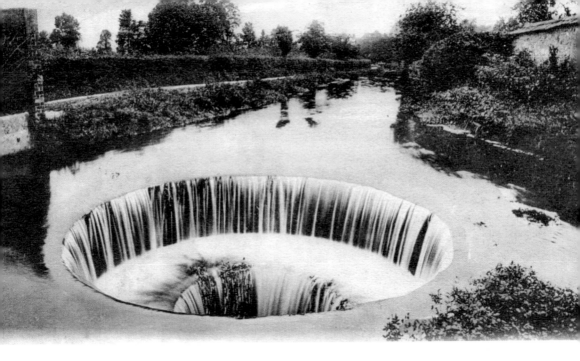

The Tumbling Weir, Looking Along Mill Stream, *c.* 1905

The path along the left provides a more tranquil walk for dog owners between the Land of Canaan and the River Otter. Sometimes kingfishers can be seen on the right bank among the trees that sit at the end of the gardens. The tranquillity is occasionally broken by natural elements, such as the flooding that occurred on 7 July 2012, shown below. Compare the picture below to the one on the preceding page.

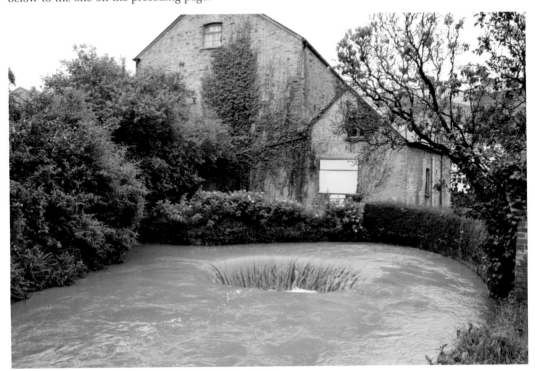

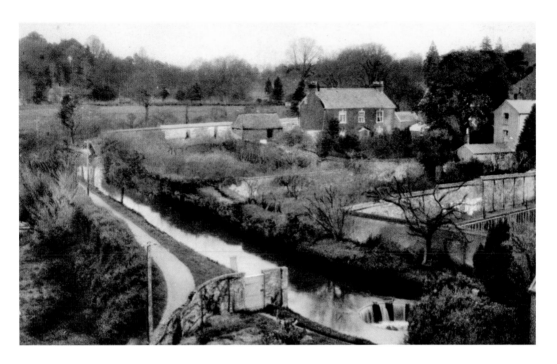

Looking Towards the Land of Canaan, c. 1910

This photograph was taken from the upper floor of the factory, looking along the mill stream towards the Land of Canaan. As the factory is closed it is impossible to get the same vantage point, so for a modern version the photograph shows the Land of Canaan playing fields with the outdoor gym opened in 2012, the playground and the statues representing Tar Barrels, Pixie Day and Samuel Taylor Coleridge. The Land of Canaan is used for many community events.

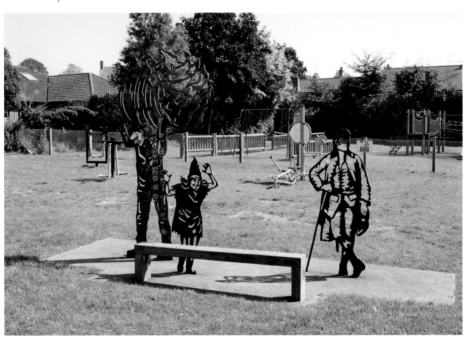

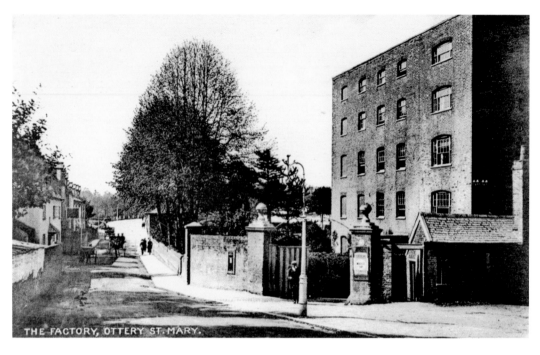

THE FACTORY, OTTERY ST. MARY.

The Factory at the Beginning of the Twentieth Century, and Derelict in 2012
Factory construction started in 1788, and by 1793 it was producing worsted thread for the
weaving trade. It immediately struggled and was put up for sale in July 1796, remaining idle
between 1796 and 1801. By 1822 it was spinning wool, to be sold in Exeter or Kidderminster
to carpet weavers, and employed between 200 and 300 people, mostly women and children.
In 1824 the factory was converted to silk spinning and weaving, and in 1839 it employed
325 persons: eighty-seven of them were aged between thirteen and eighteen, six were aged
between nine and thirteen, and two were under nine years old.

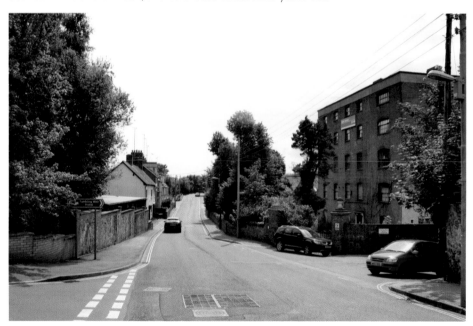

Main Gate of the Factory, *c.* 1907, and Awaiting Development, 2012

In 1898 the factory was leased to Edward Colebred, whose diverse businesses in the factory included agricultural and medicinal chemicals manufacture, mineral water production and bottling, paper bag manufacturing, printing and electrical engineering. Under Colebred, the factory produced Ottery St Mary's first electric power in 1912, generated by turbines housed in the old wheel pit. The factory was vacated in 1938. In 1947, it was purchased by GM Engineering (Acton) Ltd, which became Ottermill Switchgear Ltd. It was then occupied by Cutler-Hammer Limited, also manufacturers of electrical switchgear, who announced in 2003 that they would be shutting the factory down. In 2012 the building is awaiting development.

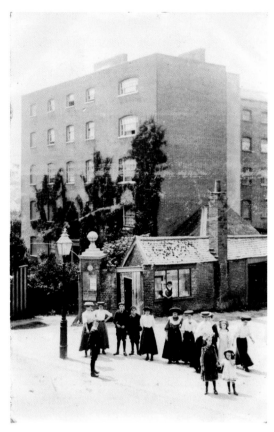

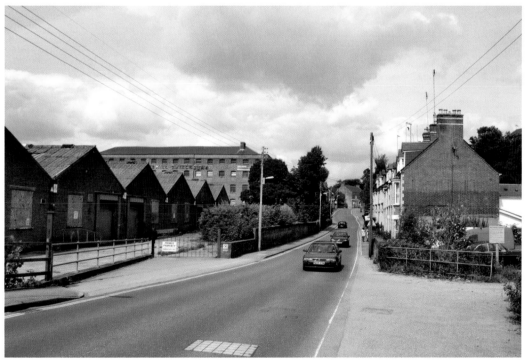

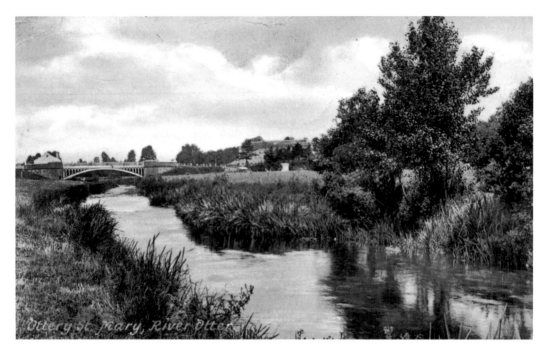

Ottery St Mary, River Otter

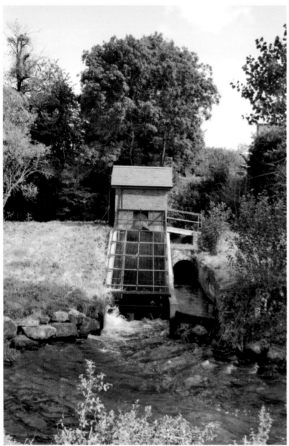

River Otter, St Saviour's Bridge and the Factory on the Right Side of the Bridge, c. 1910

Historically, the river provided drinking water and power for the mills. In 1911 the first electricity for Ottery St Mary was produced by the use of a turbine (waterwheel) in the factory. It was clear that this did not supply sufficient power for the town, and it was soon replaced by more reliable electricity generation. Water power is once again becoming popular, and in 2010 Western Renewable Energy constructed a small hydroelectricity plant, consisting of a screw turbine, just outside Tipton St John, shown left in 2012.

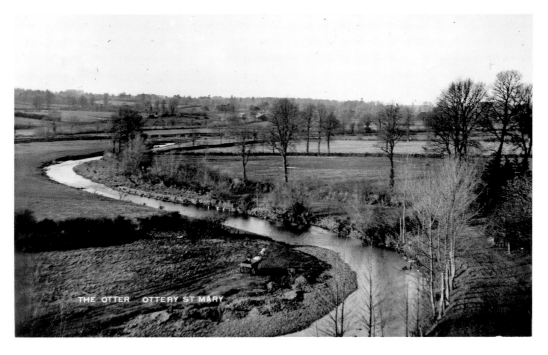

The River Otter, *c.* 1910

The River Otter starts near Otterford in the Blackdown Hills and reaches the sea at Budleigh Salterton. Today the river and its floodplain are a popular walking location, especially for dog owners and birdwatchers, and are still used to graze cows.

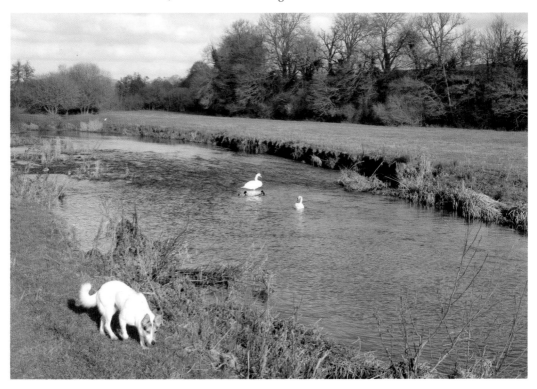

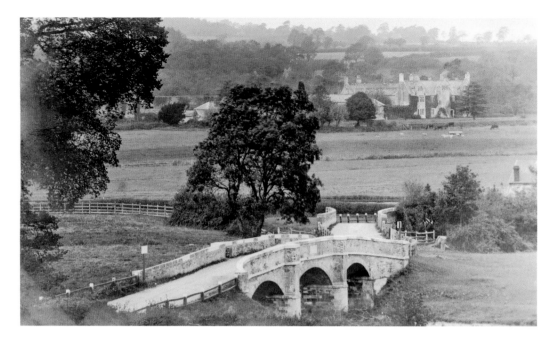

Cadhay Bridge with Cadhay House in the Distance, 1904

After taking ownership of Cadhay House in 1527, John Haydon found that the existing bridges over the River Otter provided only circuitous journeys to the town and church. He resolved this by building a bridge near to his home. Originally known as New Bridge, by 1708 it was known as Caddy Bridge. John Haydon dedicated the bridge for public use in agreement with the local authority, so that his family would not be liable for repair costs to the bridge. Below, Cadhay House can be seen in the distance from the bridge in 2012.

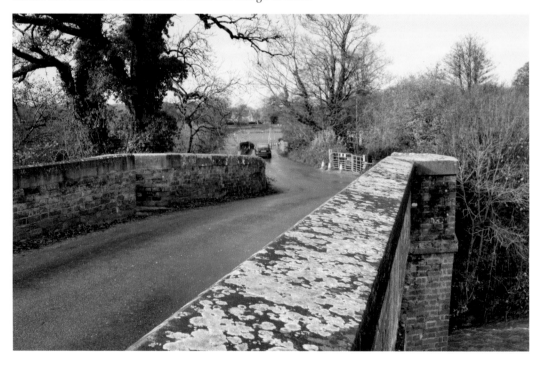

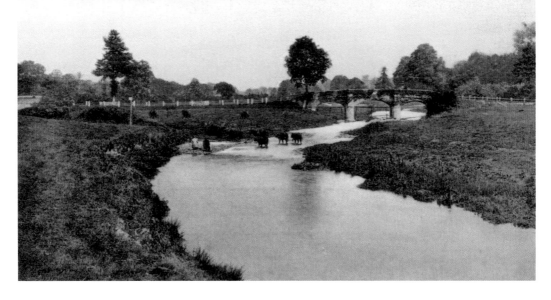

At Cadhay Bridge, Ottery St. Mary

Cadhay Bridge, 1909

In 1708, Caddy Bridge was damaged by flooding, and instructions were given to take down a damaged pier and two damaged arches. In 1754, flooding destroyed two of the arches, leading to its rebuilding in 1755. Records of 1809 show the bridge to be 'very old and bad'. James Green built the bridge we see today. The abutments and piers are high above the riverbed, in recognition of the river's ferocity when in flood.

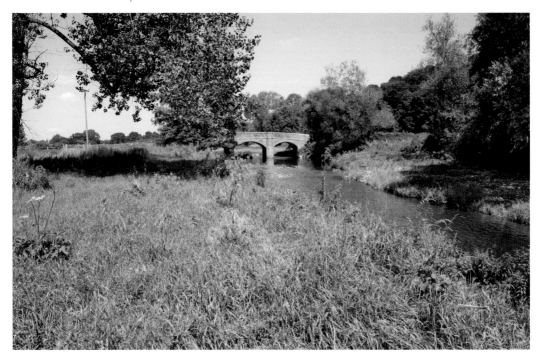

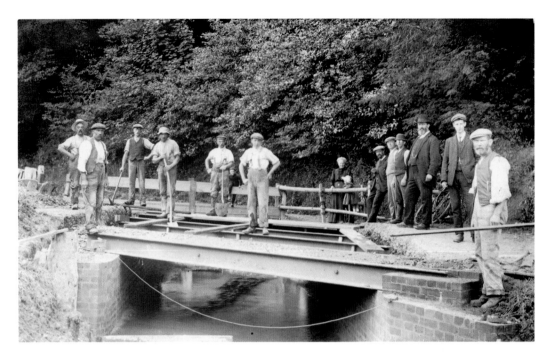

The Replacement of Sitting Bridge, *c.* 1907

Sitting Bridge lies over the mill stream on the road out to Cadhay. The workers in the picture are under the supervision of Mr F. Luxton, This photograph was taken by H. D. Badcock, who captured many scenes in Ottery St Mary in the early twentieth century. This is one of the main roads into Ottery St Mary, pictured below in 2012.

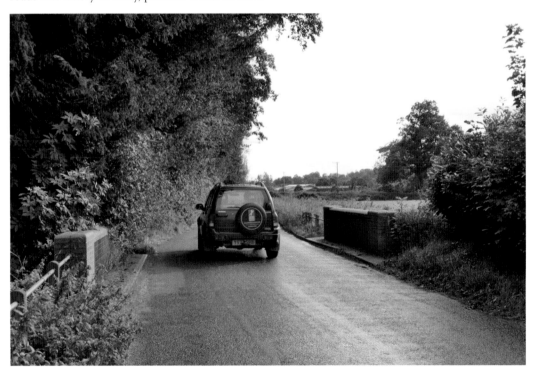

Flooding, 2008, and Big Freeze, 2010

Recent years have seen some poor weather. In 1997 the town was flooded, which led to a £4 million flood defence scheme being completed by 2004. Unfortunately, it was unable to deal with the events on 30 October 2008, when a freak hailstorm caused flooding 5 feet deep in parts. In areas the hail left ice a foot thick (above); people had to be rescued from their houses and the hospital became a shelter for twenty local residents. In December 2010, Ottery St Mary found itself snowed in for a day. The weather made for picturesque walks along the River Otter.

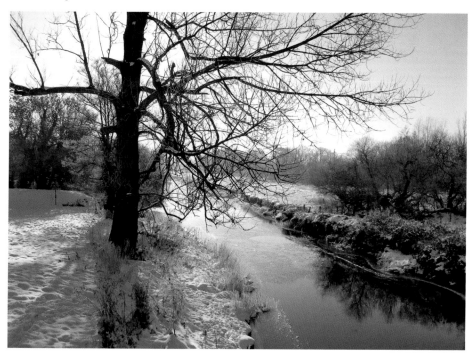

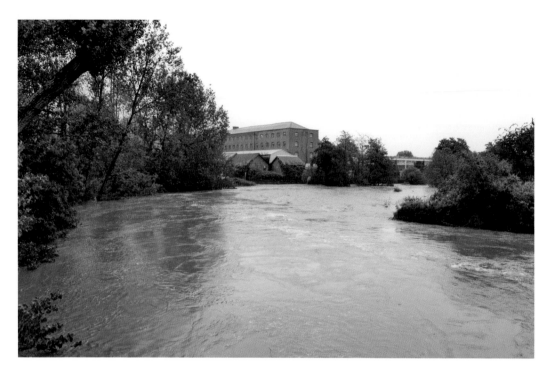

Flooding 7 and 8 July 2012, Showing the Old Factory from Coleridge Footbridge
On 7 July 2012, a month's rainfall fell in twenty-four hours. Luckily the flood defences installed in 2004 worked, and most of the residents avoided serious damage to their property. The River Otter burst its banks and the whole floodplain was filled with fast flowing, sediment-rich water. Amazingly, within twenty-four hours the river was almost back to its usual levels.

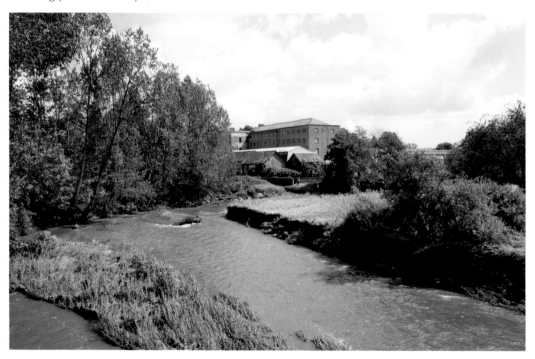

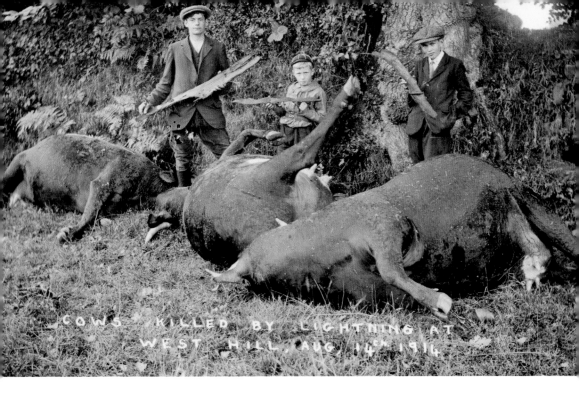

Cattle Killed by Lightning in West Hill, 14 August 1914
Cattle are still a common site in the fields around Ottery St Mary. They are mostly used for dairy, some of which produces the famous Devon cream.

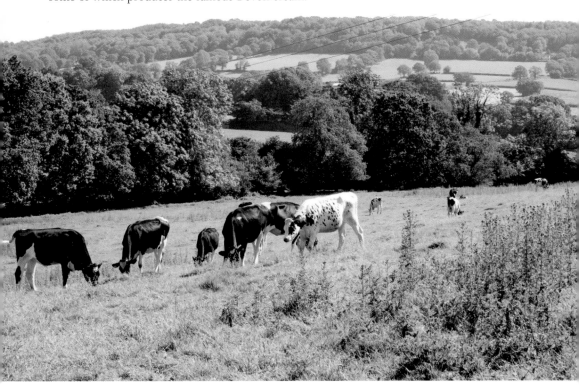

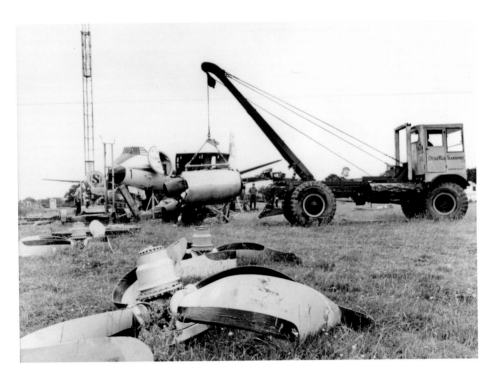

On the Flight Path

The tranquillity is sometimes broken as the noise of a plane coming into land at Exeter airport dominates. Usually the inconvenience is nothing more than noise, but on Thursday 17 July 1980 the town narrowly avoided a disaster. A plane with fifty-eight passengers and four crew members flying from Spain to Exeter ran out of fuel. The captain made a controlled landing in a field near to Salston Manor, the only casualties being four luckless sheep in the field, which were killed. The plane was dismantled so it could be removed from the field.

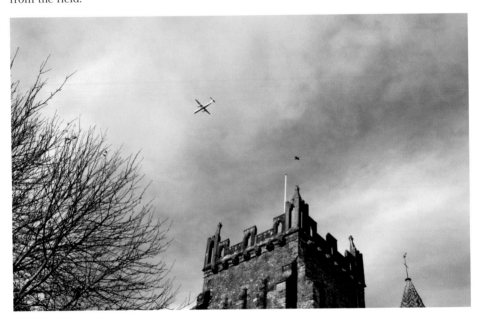

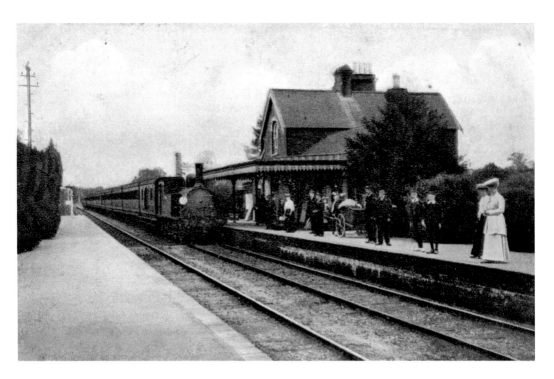

Ottery St Mary Railway Station *c.* 1907

The station was opened on 6 July 1874 by the Sidmouth Railway Company and was part of the line to Sidmouth. In 1923 the line was absorbed into the Southern Railway and was then run by British Railway after nationalisation in 1948. It was not profitable and closed to passengers on 6 March 1967, and on 8 May 1967 freight traffic ceased also. Today the station building is home to 'The Station Youth Centre' and is surrounded by industrial units, shown below in 2012.

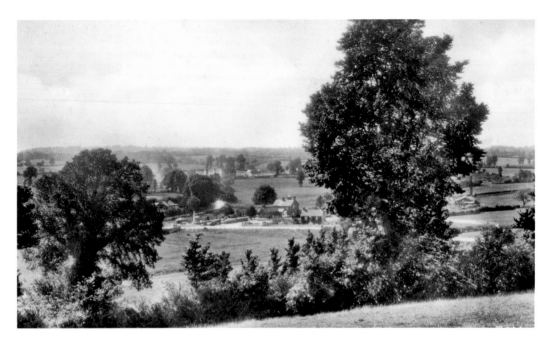

Ottery St Mary Railway Station with Level Crossing, *c.* 1940
As the railway line follows the River Otter Valley it is on flatland. This meant that it crossed over many of the roads in the area and level crossings were common to protect the public. Even though the railway is long gone, some of the gates used at the crossings are still visible, like this one on the road to Cadhay.

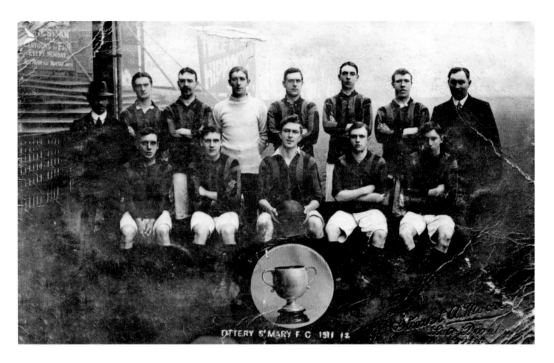

Ottery St Mary F C 1911 12

Ottery St Mary Association Football Club, 1911/12

The club was formed in 1911 using funds from the winding up of Ottery St Mary Rugby Club that had happened four days earlier. The club has played at four grounds since 1911 – The Old Sawmills/St Saviours Bridge, Shutes Meadow and Slade Road, moving to its present ground at Washbrook Meadows in 1960. The social club opened in 1986 with matches against Nottingham Forest and Queens Park Rangers, who at that time were both in the English First Division. It is not clear if Ottery St Mary Argyle FC shown below in 1921 is the same club.

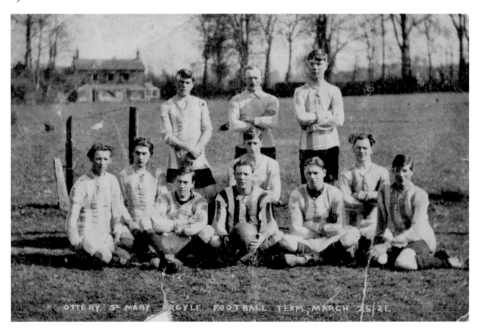

Ottery St Mary Argyle Football Team, March 25/21.

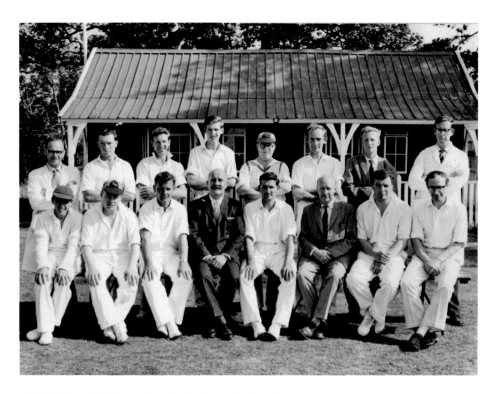

OSM Cricket Club in 1964 and the Second Team in 2011

Ottery St Mary Cricket Club was founded in 1858. To mark their centenary in 1958 they played a match against Somerset County Cricket Club and played them a few more times in the 1970s and 1980s, which brought great international cricketers like Ian Botham and Vivian Richards to the ground. To mark the 150th anniversary of the cricket club in 2008, the clubhouse was redeveloped and the new building is shown in the picture below.

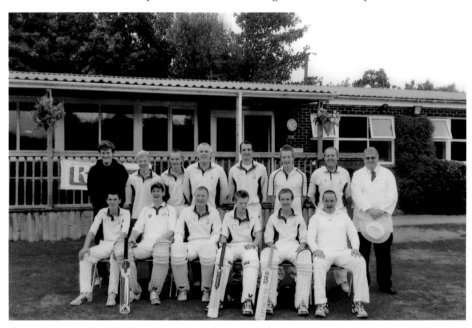

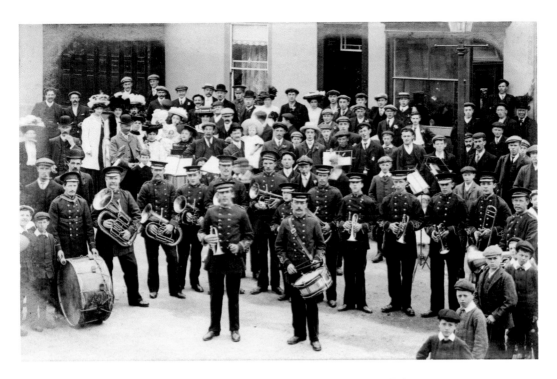

The Town Band, *c.* 1910, and at Cadhay for Queen Elizabeth II Jubilee Party, June 2012
There are references to a town band in the late 1800s, but the current Silver Band was formed after the First World War using brass instruments. After using several facilities for training they moved into a room below the Town Hall, which is still used by the band today.

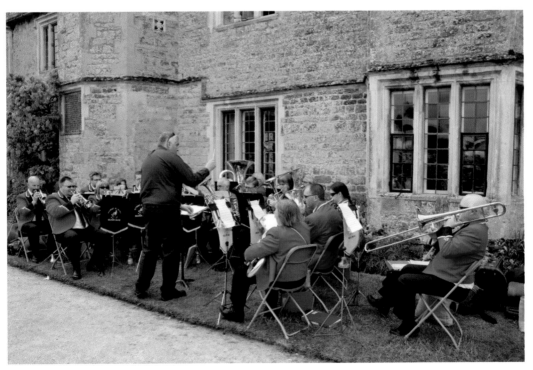

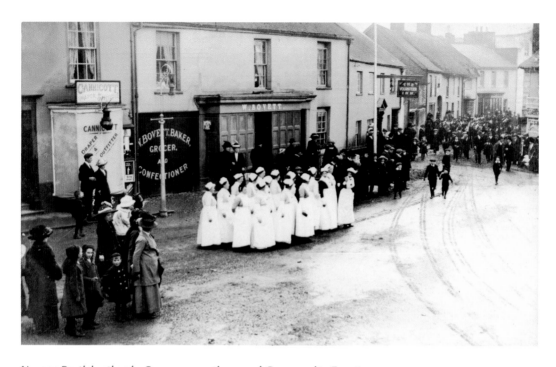

Nurses Participating in Commemorations and Community Events

Nurses have often taken part in community events, as shown by those participating in the Territorial Sunday Church Parade, November 1912. However, it usually isn't as visible as in the case of hospital nursing staff Amanda Ephgrave, Natasha Wood and Sepali Godakamda, who served jubilee tea to the patients to enable them to celebrate Queen Elizabeth II's Golden Jubilee in June 2012.

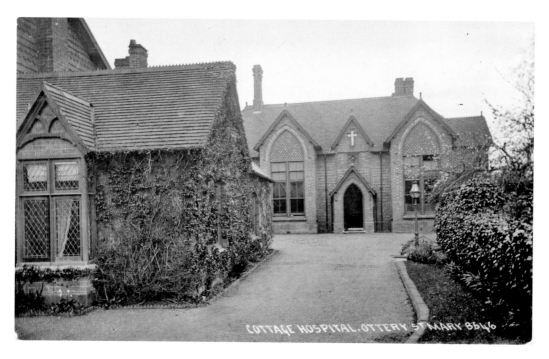

Cottage Hospital, *c*. 1910

In 1871, Isabella E. Elliot founded the hospital in Ottery St Mary. She personally funded the hospital until 1893 and then gifted it to the town. When the hospital moved to its new location in 1995, shown below in 2012, the memorial stone to Isabella Elliot was placed in its entrance. The old hospital has been converted into houses. To the shame of Ottery, Isabella Elliot, who had spent all her wealth on the care of Ottery residents, died a pauper in Winchester in 1902.

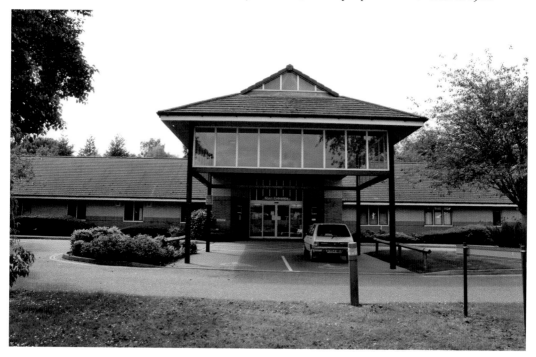

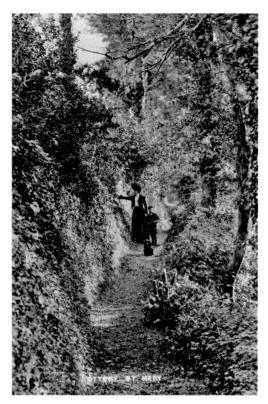

A Family Walk on a Shaded Path, *c.* 1913
The young boy carries a toy hoop and
the dog sits patiently posing for the
photographer. Today the family walk with
the dog is still a common sight along the
riverbank and country lanes, as shown by
Della and Ali Adams with their dog in 2012.

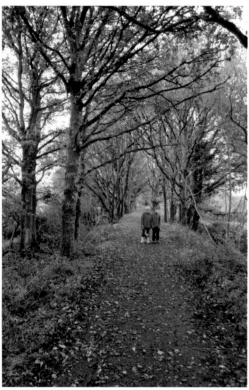

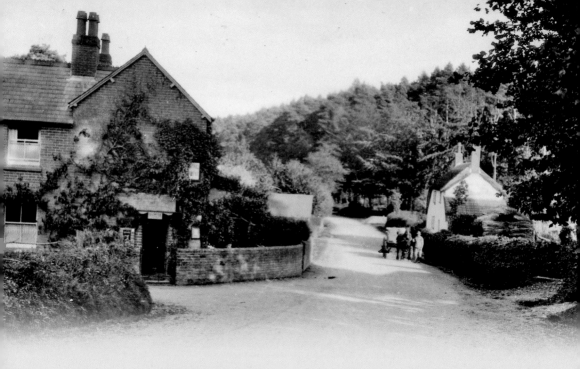

Surrounding Settlements

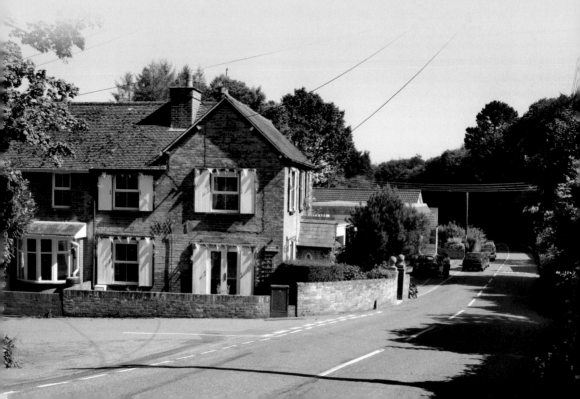

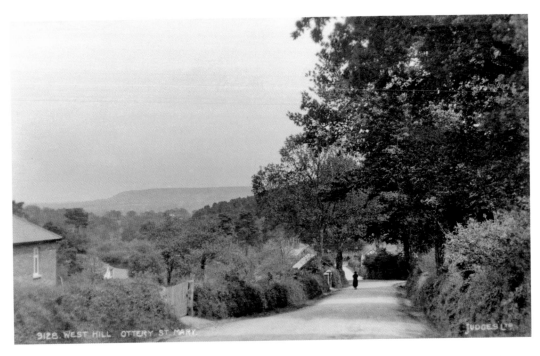

West Hill, Looking Down Bendarroch Road to the Junction with West Hill Road, *c.* **1926**
Up until the late 1960s West Hill was a quiet rural village containing some large houses. In the early 1970s Ottery Urban District Council started to expand West Hill to accommodate 3,000 people and many of the large estates were developed by demolishing the large houses and building on their land. By the mid-1970s a problem with sewage halted further development and today it is home to about 2,000 people. The previous page shows West Hill post office which is now a private house.

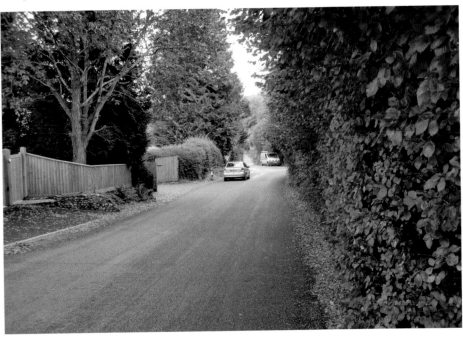

Advertisement for the Warren House Hotel, 1972

The Warren was built as a private house at the turn of the twentieth century. In 1952 it was purchased and converted into a hotel with eight en-suite rooms, a swimming pool and tennis courts. In the early 1970s, the owner, Mr Brown, was approached to demolish the house and develop the land, and this became the Warren Park housing development. Today the only evidence of the estate is in the street names Warren Park and Warren Close, shown below in 2012.

Just Relax
and take it all in

Have a real holiday right in the heart of some of the loveliest touring countryside in Devon—the beauty of Exmoor; seasides at Exmouth, Budleigh Salterton, and Sidmouth; historic legacies in the ancient city of Exeter —all within a 15 mile radius of Warren House Hotel. This extremely comfortable hotel stands in secluded and picturesque grounds that compel you to relax and just take it all in· Bring your golf clubs and fishing tackle and if you feel energetic, there's plenty of places to use them near here.

Another good thing about Warren House Hotel—you don't have to tackle the Exeter by-pass to get there.

▶ **Warren House Hotel.**

West Hill, Ottery St. Mary, S. Devon
Telephone: Ottery St. Mary 2626

★ Licensed Open for all meals and snacks ★

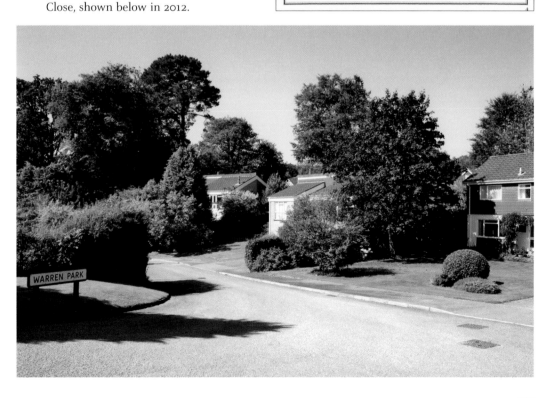

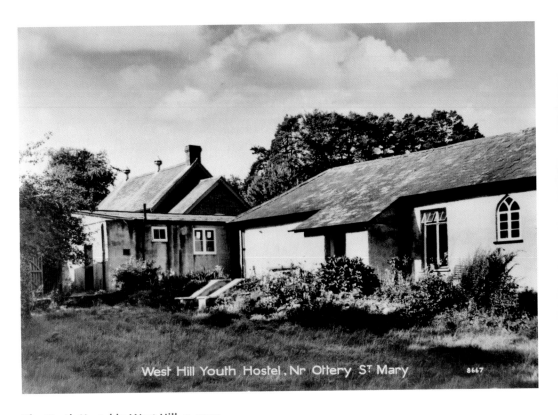

West Hill Youth Hostel, Nr Ottery St Mary 8667

The Youth Hostel in West Hill, *c.* 1945

The youth hostel was ideally situated for walkers. Unfortunately it was closed in the 1950s and demolished to make way for housing. There are now few places for visitors to stay in the Ottery St Mary area, but small guesthouses and bed & breakfast at farms try to meet the need.

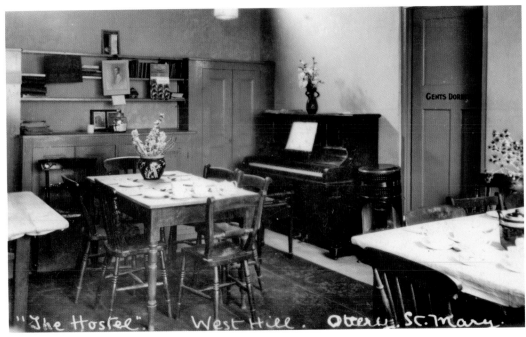

"The Hostel". West Hill. Ottery St Mary.

Broad Oak, *c.* 1910
Broad Oak lies to the east of West Hill. Development has encroached upon the farmland, but for much of the area little has changed over the last century, and it maintains its rural appearance.

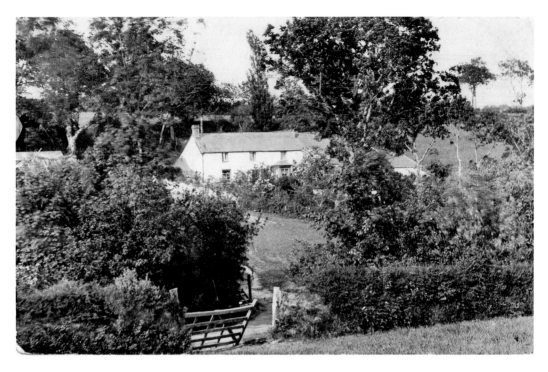

Westbrook Farm, Metcombe, *c.* 1910
Metcombe is a small village to the south-west of Ottery St Mary, surrounded by farmland and farm buildings. The village itself has some quaint old buildings such as Brookside Cottage, shown here in 2012.

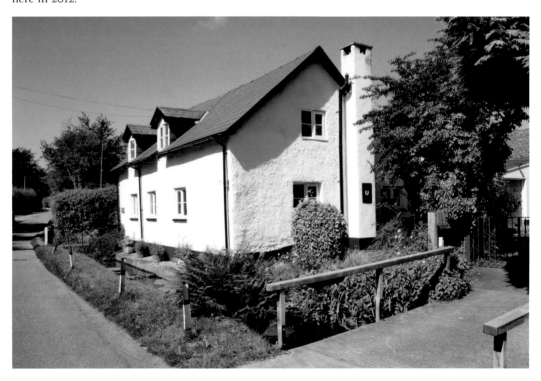

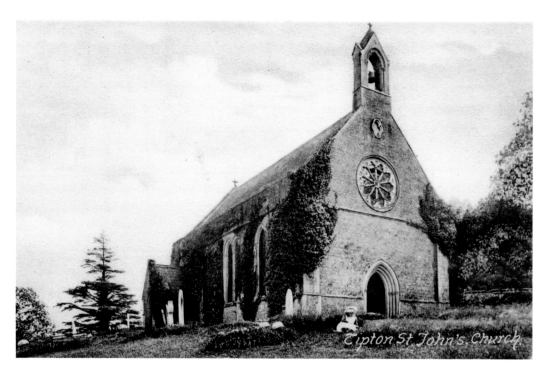

St John the Evangelist Church, Tipton St John, *c.* 1910
In 1837, as Ottery St Mary was expanding, a new parish was formed at Tipton and St John's church was consecrated in 1840.

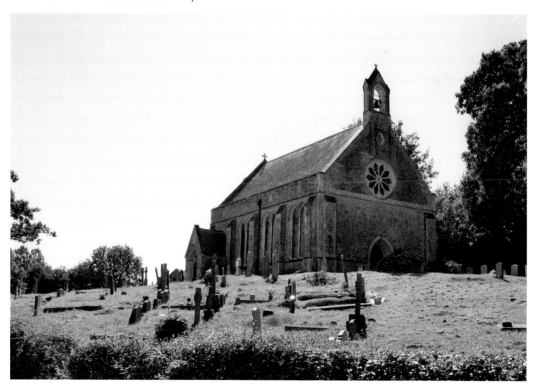

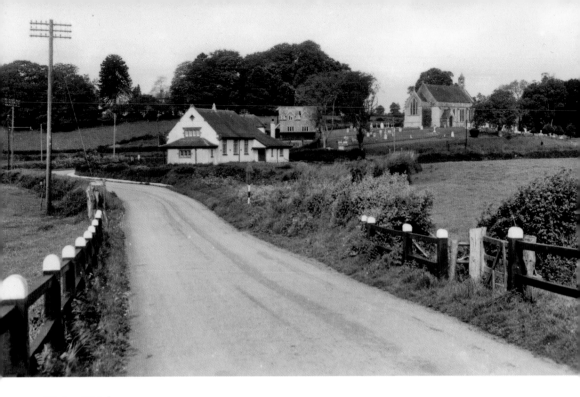

Tipton St John, 1920s

Since this photograph was taken, the area has seen extensive tree growth and the construction of new properties such as the primary school. The trees hide the buildings shown in the 1920s photograph, but the church roof can be seen on the right.

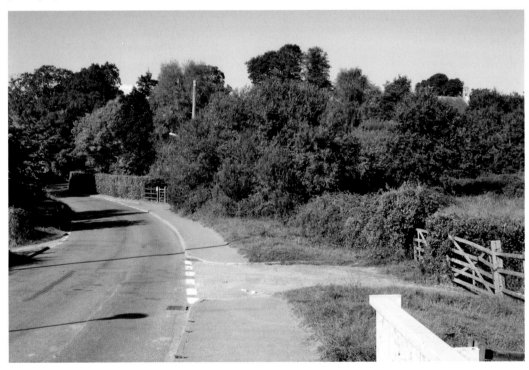

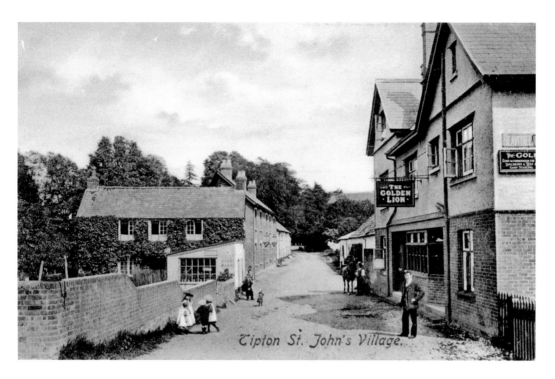

Tipton St. John's Village.

Tipton St John, *c.* 1910

The two focal points of Tipton St John are the Golden Lion pub and the church. There is a small village shop, but the post office which was opposite the pub was closed in 2008. One of the surprises of the village is the Tipton Garage which has several historic cars visible through the showroom window.

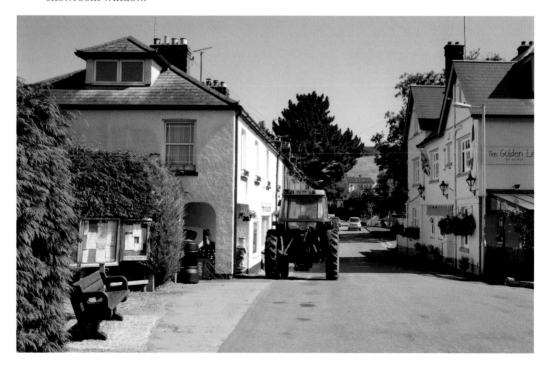

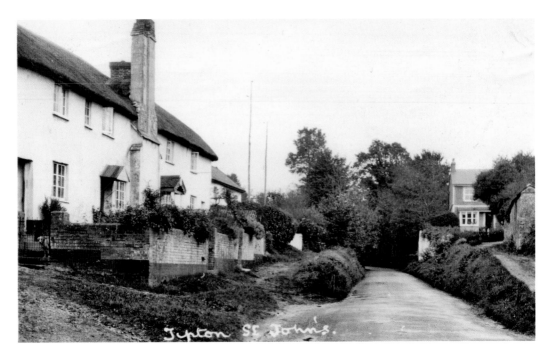

Tipton St John, *c.* 1910

The above photograph was taken by Badcock & Sons of Ottery St Mary. Sometimes you wonder whether the photographer was taking the photograph as a speculative income generator, whether they were commissioned by one or more of the house owners, or even if they were trying to record the social history of the area through their work.

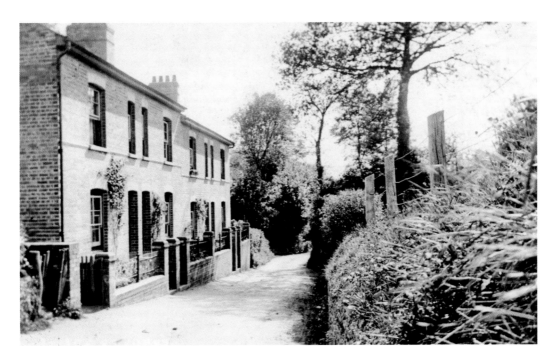

Workers' Cottages, Tipton St John, *c.* 1909

These workers' cottages are on the road entering Tipton St John from the east at Tall Timbers. Since the earlier photograph was taken the run of houses has been extended slightly. What is more noticeable though has been the widening of the road to accommodate increased motorised traffic.

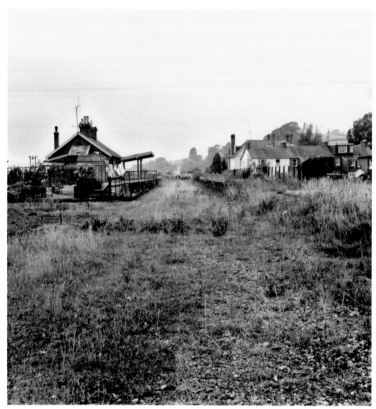

Disused Railway Station at Tipton St John, *c.* 1970
Time is doing a great job in hiding the signs of the old railway line. However, remnants of the old railway infrastructure can be found, for example old level crossing gates are found on several roads and the bridge over the River Otter still exists just outside Tipton St John, shown below in 2012. The old raised railway line provides an ideal walking route especially between Ottery St Mary and Tipton St John.

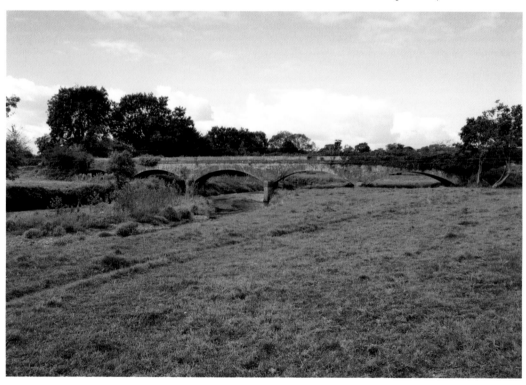

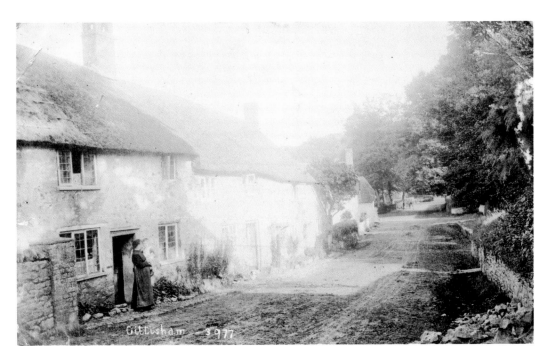

Gittisham, *c.* 1907

Gittisham still remains as an example of what one would expect from a typical Devon village. Most of the houses in the old centre have thatched roofs, the old water pump still works, the church is a focal point of life and has a well-used graveyard, and, as in many other villages, the old school has been converted into houses.

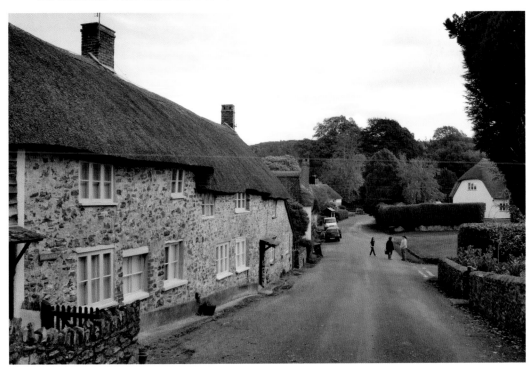

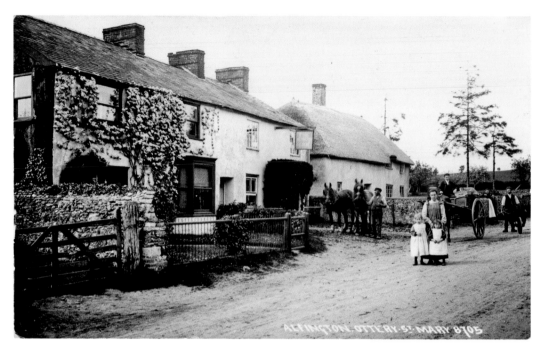

Alfington Inn, Alfington, *c.* 1910

Like many rural pubs, the Alfington Inn was unable to survive as a business and closed in 2007. It has now been converted into a private house, but the frame for the old pub sign still remains. Throughout the years surrounding properties have been demolished leaving only a part of the building shown *c.* 1910 standing today.

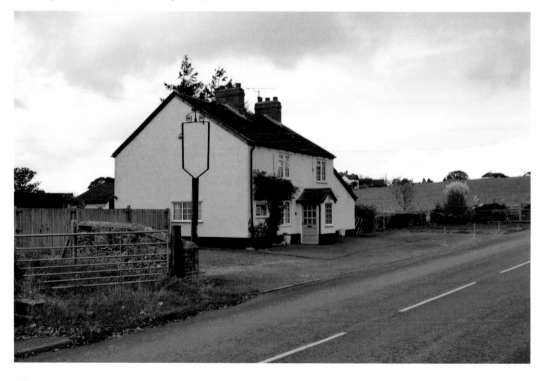

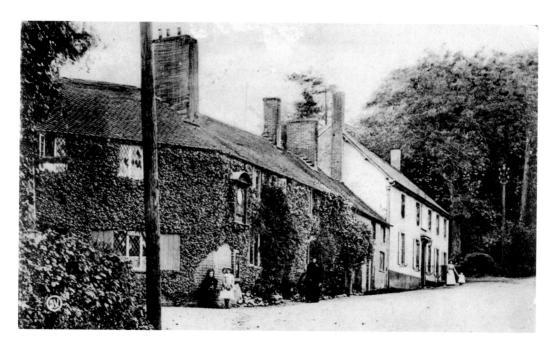

The Post Office and Fairmile Inn, Fairmile, 1907

The large post office clock was erected in 1897 to commemorate 'Sixty Years of Blessing' – sixty years of Queen Victoria's reign. It has been the responsibility of the residents of Fairmile Cottage to wind up the clock weekly. Fairmile Inn was built in the sixteenth century and became the coach stopping point for Ottery St Mary. It probably takes its name from the nearby stretch of the London–Exeter coaching road, which, it was claimed, was fair (better).

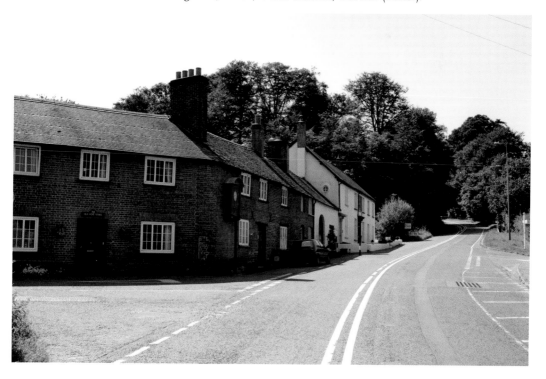

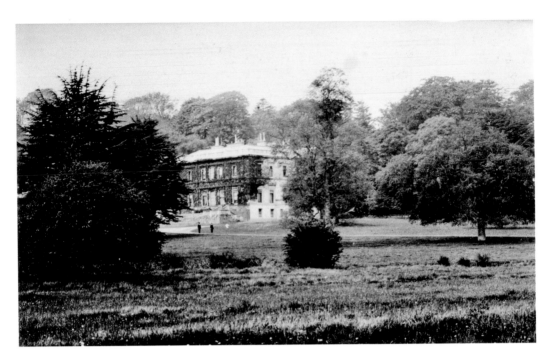

Escot House, c. 1910

Little is known of Escot estate in the early days after its first mention in 1227. In 1680 Walter Yonge purchased the estate and commenced the building of a new house, entirely in brick. In 1794 the Yonge family's financial problems forced them to sell to the Kennaway family. In 1808 the house was destroyed by fire, and it was not until 1837 that the building of a new house was undertaken, using rubble from the previous house for the foundations.

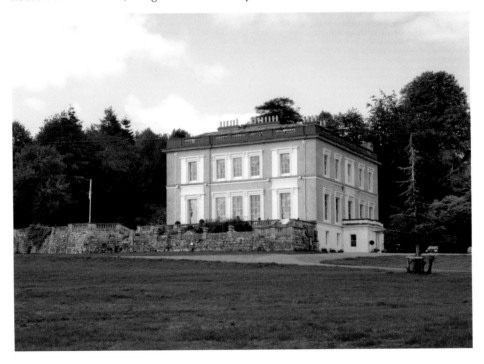

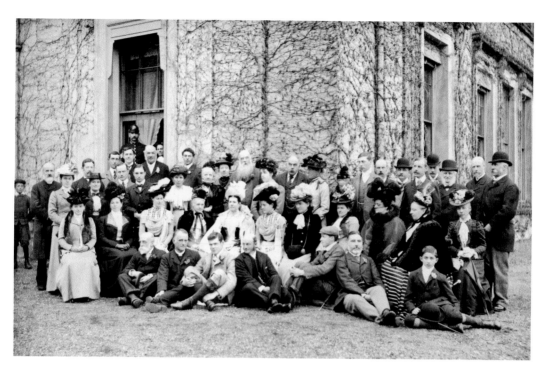

Escot, April 1900

Through the years, Escot has held many private parties for the family and community, illustrated by the family celebrating the coming of age of John Kennaway on 17 April 1900 (*above*). In the 1980s the family opened up their home and gardens to the public for corporate and private functions, particularly marriages. Below, the author and his wife Victoria are pictured after their wedding in the library at Escot in April 2012. Today Escot has a wildlife area housing otters, birds of prey, wild boar, red squirrels and a petting zoo.

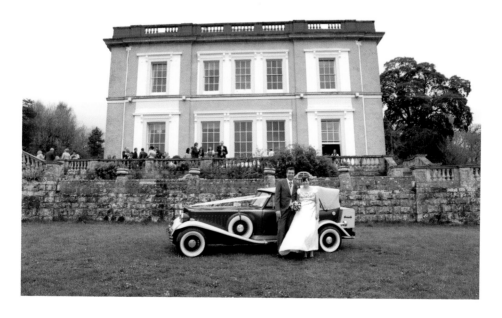

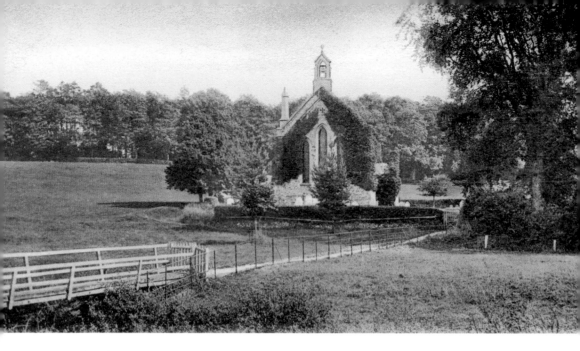

Escot Church, c. 1910

St Philip and St James church, also known as Escot church, was built by Sir John Kennaway, the owner of nearby Escot House. He travelled to the church in Talaton for worship, but in 1839 he started to build a church on his land for the local community. It was consecrated in 1840.

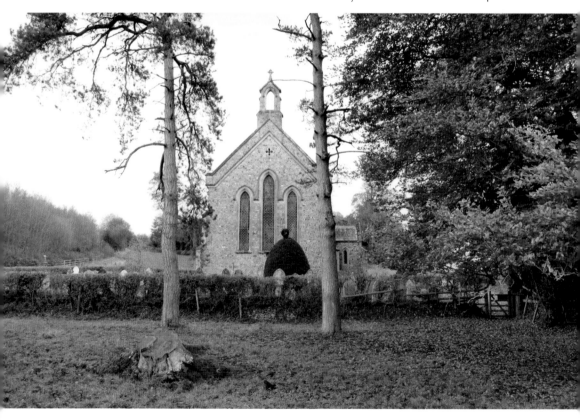

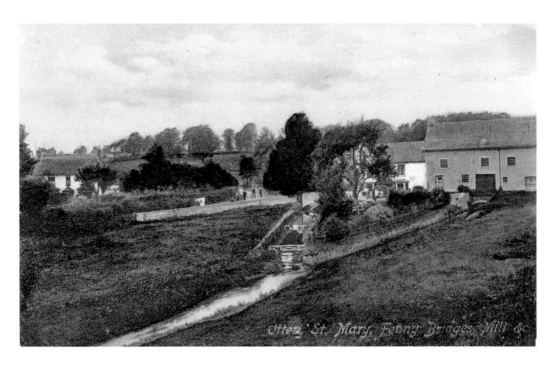

Mill at Fenny Bridges, *c.* 1910

The old stream to the mill is now hidden behind a line of trees. Many people may recall the name of Fenny Bridges from the protests against the development of the A30 in the 1990s. Near to Fenny Bridges and Fairmile a camp was set up by environmentalists protesting against the road development. The most famous of the protestors was 'Swampy'. They failed, and a new stretch of the A30 opened to the north of the old A30.

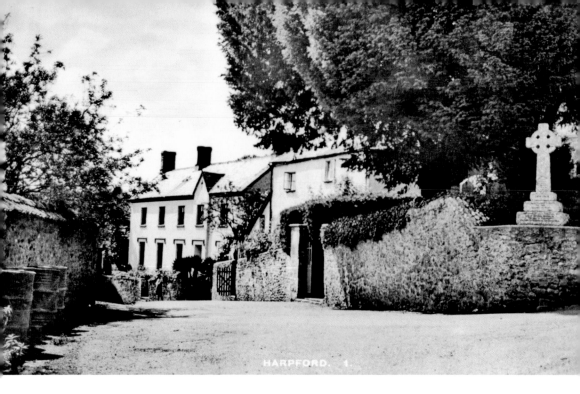

Harpford, c. 1910

Even though Harpford falls just outside the Ottery St Mary 'Devon Town' boundary, several images have been included. Ottery St Mary residents married people in the nearby villages and towns, expanding the influence of the old market town, and residents and farmers from Harpford would have attended the regular markets and events in Ottery St Mary. The large house on the left, Court Place, is still present, but the house on the right has been demolished.

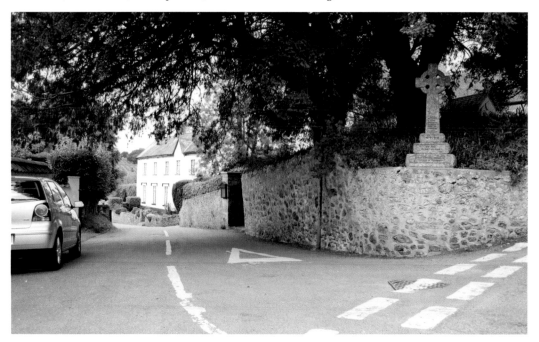

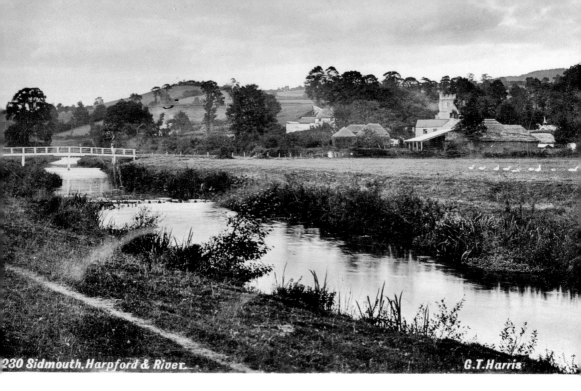

230 Sidmouth, Harpford & River. G.T.Harris

Harpford and the River Otter, *c.* 1920
Harpford was formerly called Happerford. St Gregory's church has a fifteenth-century tower, but most of the rest of the building was restored in 1884.

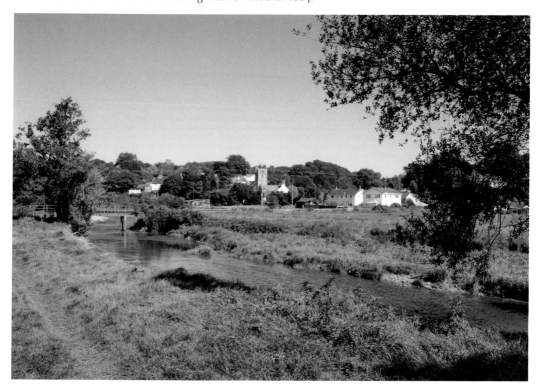

Acknowledgements

I would like to thank my parents, Paul and Elizabeth Sadler, who gave me my interest in history, and my wife Vicky, who has supported me through my work on this publication and shares my interest in the past.

All of the historic photographs have come from the archive of Sands of Time Consultancy, with the exceptions of the following pages 26, 35, 40, 45 and 71, which have been supplied by Linda Gill, page 91 by Lucy Kennaway, Escot Estate, pages 18, 19, 22, 23, 24, 25, 28, 36, 39, 41, 42, 43, 44, 46, 47, 48, 49, 63, 65, 69, 72 and 73 by Peter Harris, page 57 by Chris Saunders and page 70 by Ottery St Mary Cricket Club.

All the new photographs have been taken by Nigel Sadler, with the exceptions of the photograph on page 70, which was supplied by Kay Dean, on pages 71 and 72 by Victoria Sadler, and on page 91 by Helena Williams.

I would like to thank all of those mentioned above who have supplied images for this publication. I would also like to thank Phyllis Baxter of Ottery St Mary Tourist Information Centre for her support and advice, the Ottery St Mary Heritage Society, Rupert Thistlethwayte, owner of Cadhay, for giving me access to his house, and to all those who gave me permission to photograph them for this publication.

I would also like to acknowledge the residents who took up photography in the early days, like A. J. Way, H. D. Badcock and R. T. Slee, who have made this book possible by recording the town through their work in the early part of the twentieth century.

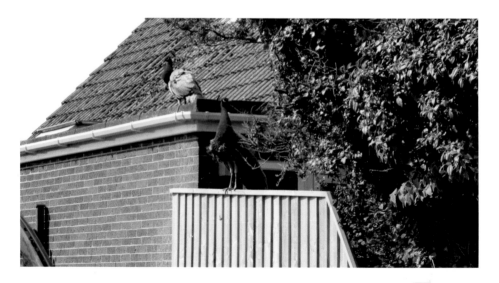

Peacocks on the Higher Ridgeway, July 2012
Walking along the River Otter it is possible to see the occasional blue flash as a kingfisher swoops past. In 2012, though, there was a much slower blue flash during the Great Peacock Mystery. From May 2012, the cries of peacocks could be heard throughout the town and occasional sightings were made of four escaped birds. They were seen in neighbouring fields, gardens and on house roofs.